IMAGES
of America

CEMETERIES OF
SEATTLE

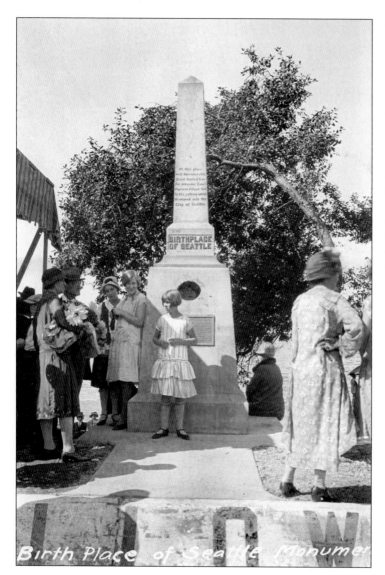

Birth Place of Seattle Monument

BIRTHPLACE OF SEATTLE. This 1929 photograph shows the monument marking the Denny party landing at Alki Point. The inscription reads, "At this place on 13 November 1851 there landed from the Schooner Exact Captain Folger the little colony which developed into the City of Seattle." (Courtesy Seattle Municipal Archives, 46980.)

ON THE COVER: A crowd surrounds the symbolic grave on Memorial Day sometime in the 1920s. Placing wreaths on a symbolic grave by veteran and patriotic organizations is a tradition at the Veterans Memorial Cemetery in Evergreen-Washelli Cemetery. (Courtesy Evergreen-Washelli Cemetery.)

IMAGES
of America

CEMETERIES OF
SEATTLE

Robin Shannon

ARCADIA
PUBLISHING

Published by Arcadia Publishing
Charleston SC, Chicago IL, Portsmouth NH, San Francisco CA

Printed in the United States of America

Library of Congress Catalog Card Number: 2007928541

For all general information contact Arcadia Publishing at:
Telephone 843-853-2070
Fax 843-853-0044
E-mail sales@arcadiapublishing.com
For customer service and orders:
Toll-Free 1-888-313-2665

Visit us on the Internet at www.arcadiapublishing.com

For my son, Jeremy, of whom I am so proud, I love you more, more, more. To my brother Ricky, who tragically died way too young. For my sister Ronda, whom I love most of the time, I dedicate this book.

To my late neighbor and friend, Ethel Gould, whom I can still hear commenting, "See, I told you, you can do anything that you set your mind to." For my lifelong friend Katie Russell (KT), I will love you always and forever, for you are always there when I need you. To Big Bird, our Cockatiel who recently died, I can still hear his welcoming sharp squawks when I walk in the house. A warm dedication to my newfound travel partner Laurie ValBush.

And last but certainly not least, I would like to dedicate this book to my mom and dad, who put up with my crazy teen years (which ran into my twenties) but always supported me, no matter what.

CONTENTS

ACKNOWLEDGMENTS

Late one moonless night, while strolling in the dark on an excursion to the Enumclaw Evergreen Cemetery (with permission) with the Washington State Paranormal Investigations and Research group (WSPIR), I turned to Patricia Woolard and asked if there were any good books she could recommend about Seattle cemeteries. "As a matter of fact, no," she said. My response to her was, "Well I am going to write one, then." That weekend, I did some research online and e-mailed Arcadia Publishing about my idea. Two days later, Julie Albright called from Arcadia, very interested in and excited about my proposal of a Seattle cemetery book. That is how this book came to be. So I'd like to give a big thank-you to Patricia Woolard, vice president of WSPIR, and Charlotte Liggett, director of psychic sciences also of WSPIR, who are boneyard buddies for inadvertently planting the seed of an idea that grew into this book, and to Julie Albright for being so encouraging and for giving me the guidance to continue when things were not going so well.

Without Evergreen-Washelli Cemetery opening their doors so graciously and making me feel so welcome, this story could not have been told in full. Warm thanks go to Paul Elvig and Sandy Matthie at Evergreen-Washelli Cemetery for their support, even when they were extremely busy with more important tasks.

Special thanks to photographer Cherian Thomas, whom I am sure I have known in a previous lifetime, for taking such awesome photographs of historical markers. Thanks to Jake (Jake@privateeyetours.com) of Private Eye on Seattle Mystery and Murder Tour for her Butterworth contact. Thanks also go to Bert Butterworth Jr. for sharing his family history and photographs. A heartfelt thanks to Jeff Ware for being so prompt in scanning historical photographs from the Seattle Municipal Archives. Thanks to Margaret Riddle from the Everett Public Library for her prompt response to my request for the "Wobbly" photographs. Thank you to John Lamont of the Seattle Public Library for pointing me to the Clarence Bagley books. Last but not least, thanks to my boss, Randy Shoults, for being so understanding and to Janet Peck for listening to my rambles.

Burial plot numbers for the individuals identified in these images have been included whenever available. These numbers follow the image courtesy lines, in the following format: "(Courtesy Cherian Photography, Lot 432.)"

INTRODUCTION

Native Americans first inhabited the land of Puget Sound. In a treaty of Port Elliott in 1855, Chief Sealth (Seattle) spoke of the differences regarding death:

> To us the ashes of our ancestors are sacred and their resting place is hallowed ground. You wander far from the graves of your ancestors and seemingly without regret. Your religion was written upon tablets of stone by the iron finger of your God so that you could not forget. The Red Man could not comprehend nor remember it. Our religion is the traditions of our ancestors—the dreams of our old men, given to them in solemn hours of night by the Great Spirit; and the visions of our sachems, and is written in the hearts of our people.
>
> Your dead cease to love you and the land of their nativity as soon as they pass the portals of the tomb and wander way beyond the stars. They are soon forgotten and never return. Our dead never forget the beautiful world that gave them being. They still love its verdant valleys, its murmuring rivers, its magnificent mountains, sequestered vales and verdant lined lakes and bays, and ever yearn in tender, fond affection over the lonely hearted living, and often return from the Happy Hunting Ground to visit, guide, console and comfort them.
>
> Let him be just and deal kindly with my people, for the dead are not powerless. Dead, did I say? There is no death, only a change of worlds.

Native American remains, traditionally, were not left alone until the time of the spirit to make the journey to the happy hunting ground. New moccasins were provided, and on the morning of the service, the bodies of the deceased were washed like newborn babies. Usually they were dressed in their best clothes. After a wake, the deceased were buried with all that they owned.

Both cremation and burials were common for Native Americans. If a member of the tribe died while away from the tribe's home area, then a cremation would take place to ensure that no physical portions of the body were left behind for an enemy to make "bad medicine" with or to interfere with the spirit journey.

Most commonly, ground burials took place in a shallow grave with slabs of cedar over the grave serving as a sort of roof. In some burials, the body was wrapped in rush mats that were laid in the ground and covered by a canoe.

The Denny party landed at Alki Point on November 13, 1851. The first known cemetery in the city of Seattle was on the land of the Denny Hotel at Second and Pine or Second and Stewart from around 1853 to 1860. An 1878 directory claimed that there were about 20 burials at this site. Most were removed and reburied.

The next known burial site was at the first church of Seattle, the Old "White Church," which was Methodist and was founded by the Reverend and Mrs. Daniel Bagley. Next to the church was a graveyard at the corner of Second and Columbia. In 1856, two young men who were killed during the short Indian War were buried here.

There were also burials in the old tide flats at Maynard's Point. In 1854, a Dr. W. B. G. Cherry was buried there when he died from wounds he received while part of a posse at Holmes Harbor. The few bodies that had been buried there were removed in September 1864.

Other burial sites were probably around the city, but with the passage of time they were forgotten. With Seattle becoming a boomtown, the Seattle Cemetery on Depot Street (now Denny Way) was started about 1861 on land donated by David Denny.

In 1864, bodies were removed from the Maynard and Arthur Denny's claims and moved to the Seattle Cemetery. In 1875, John Denny (father of Arthur and David Denny) was buried at the Seattle Cemetery.

On January 3, 1873, a Seattle ordinance made the Seattle Cemetery official, with plots to be sold for no less than $10 each. The mayor at that time was to appraise the lots. The Seattle City Council was to appoint a city sexton who would be in charge of the cemetery. The sexton was to keep track of all sold and empty lots, be in charge of burials, keep the cemetery clean, sell the lots, keep all records, arrest anyone breaking the law in the cemetery, and appoint his own successor.

Ordinance No. 346 passed in January 1883, requiring both birth and death certificates.

During the gold rush of the late 19th century, many men with gold-lined pockets were robbed and killed on the streets of Seattle and then dumped into Elliott Bay. King County offered $50 to any funeral director who would pick up and dispose of these bodies properly. One can imagine several funeral coaches racing down the hilly streets of Seattle, rushing to be first to collect the body.

In 1870 or 1871, on land at the top of Capital Hill belonging to Dr. Maynard, a new cemetery named Lake View was born. Lyman Bonney, Dr. Maynard, and C. C. Shorey formed the Seattle Masonic Cemetery Association, which was related to the Masons in name only. An April 26, 1873, article in the *Weekly Intelligencer* described this new cemetery: "Turning to the west, we see the vast expanse of Puget Sound, with its bold headlands, one above another, and beyond them the rugged, craggy peaks of Olympus and the Coast Range sharply outlined against the sky. Without doubt, the Association selected the most fitting location for the 'City of the Dead.' "

On May 9, 1873, Mrs. L. P. Smith was buried at Lake View Cemetery. Doc Maynard was buried on May 10. A total of 237 plots were filled by 1878, mostly as reburials from other cemeteries. Another huge part of this cemetery was set aside for Chinese burials.

During the late 1800s, Duwamish Cemetery came into being in west Seattle, with burials of the poor and from county hospital.

In February 1884, bodies were removed from the old Seattle Cemetery so it could be turned into a public park, and the 223 bodies were dug up and reburied at the Masonic cemetery (Lake View), the new municipal cemetery (currently Volunteer Park), the new Catholic burial ground, Washelli (Evergreen-Washelli), Oak Lake and Mount Pleasant. The City of Seattle paid O. C. Shorey $3,000 to make new cedar boxes and to exhume and rebury the dead. During the regrading of Denny Hill, some missed burial plots became apparent; in the midnight hour, they were quietly removed and reburied. Legend has it that this is where the term "graveyard shift" comes from.

First Washelli Cemetery was the new municipal cemetery (currently Volunteer Park) on top of Capital Hill, built on 40 acres bought by Seattle in 1876 for $2,000.

I hope that you enjoy these photographs as much as I have and that you learn something about our Seattle history. This is my view of history, and I am sure that if someone else were to assemble a pictorial book on the subject it would have a different view. Enjoy!

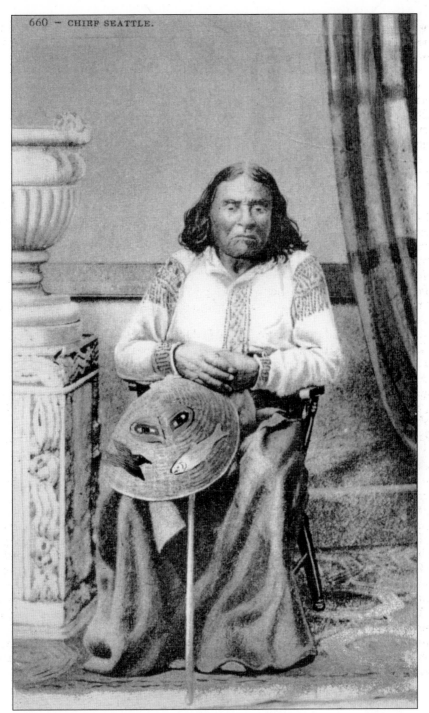

CHIEF SEATTLE. Taken by E. M. Sammis, Seattle's first photographer, only this one photograph exists of Chief Sealth (Seattle). Sealth was studying portraits of settlers displayed in the photographer's window when Sammis motioned the chief inside. The original image features Sealth with his eyes closed. Doctored copies show his eyes open, as in the postcard pictured here. (Courtesy Cherian Thomas Photography.)

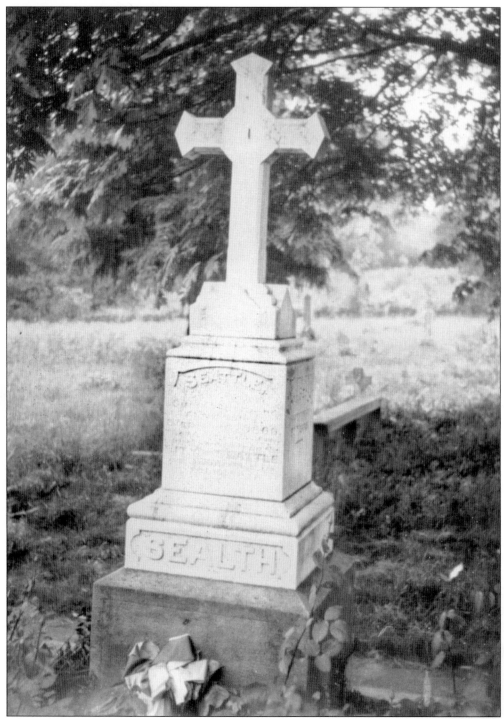

CHIEF SEALTH MEMORIAL. Sealth was born in 1786 and was given the Lushootseed-language name "Siʔal." Early pioneers gave him the name Seattle because they could not pronounce his name. Sealth died in 1866. His grave lies in a small cemetery behind the St. Peter's Catholic Church on Washington's Kitsap Peninsula.

One

LAKE VIEW CEMETERY

Beneath the ground of Lake View Cemetery is some of Seattle's richest history. Most Seattle pioneers are buried within Lake View Cemetery, which was the city's major burial ground from the late 19th century to the early 20th century. Prominent Seattle pioneers include the Dennys, the Maynards, the Mercers, the Morans, and the Yeslers. Bruce Lee and Brandon Lee are also buried in this picturesque cemetery high atop Capitol Hill at 1554 Fifteenth Avenue East, just north of Volunteer Park.

Established in 1872 and purchased by the members of the St. John's Lodge of the Order of Free Masonry, the land was bought from Doc Maynard. Before the burial sites at Lake View existed, in 1855 graves were dug east of Maynard's Point or at the White Church, Seattle's first church, or at the old Seattle Cemetery, located on the north side of the Denny Regrade. Many of the persons buried at those sites were dug up and reburied elsewhere and eventually ended up at their final resting place in Lake View.

Harry Watson of Bonney-Watson was sexton, and his partner Lyman Bonney was manager. Those two partners in life are now partners in death, buried toe to toe in this cemetery. For three recent generations, the Bladine family has managed Lake View Cemetery.

Memorial stones and markers of the past were made of slate and soft marble, with lengthy carved epitaphs. Many of the soft stones, although beautiful and easy to work with, have deteriorated in Northwest weather. Huge massive monuments and family plots were common for the times. Today's graves are typically indicated by plain sandblasted granite headstones or markers, or a person is simply cremated.

In 1911, a site was dedicated "to the Memory of Confederate Veterans." In 1926, a memorial was erected. In the northeast corner of the cemetery is the Nisei War Memorial Monument, dedicated in 1949 to Japanese American Veterans.

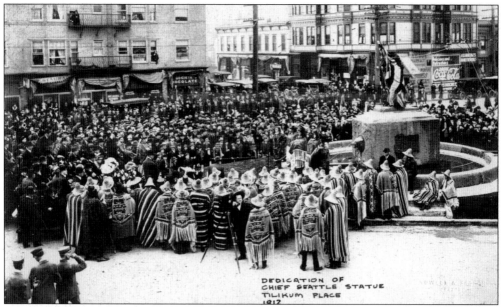

DEDICATION OF CHIEF SEATTLE STATUE. On November 13, 1912, Founders Day, a crowd gathers for the dedication of the Chief Seattle statue at Tilikum Place. Photographer F. H. Nowell took the historical photographs in downtown Seattle. Tilikum Place (*tilikum* means "welcome" or "greetings" in Chinook) is located at the corner of the original land claims of Denny, Boren, and Bell. Myrtle Loughery, the great-granddaughter of Chief Sealth, did the unveiling. Sealth stands on a pedestal wrapped in a stained copper shawl, with one arm raised in a symbolic greeting to the first white settlers, who landed at Alki Point in 1851. (Courtesy Seattle Municipal Archives 30406, 30412.)

LAKE VIEW CEMETERY. Up at the top of Lake View Cemetery at the base of a giant Redwood Sequoia is a grey granite bench near the Whitebrook family graves. These words, inscribed on the bench, perfectly describe historic Lake View Cemetery: "East the mighty Cascades run free / North is the university / South, a great tree / West, lies the Sound / All these places were loved by me."

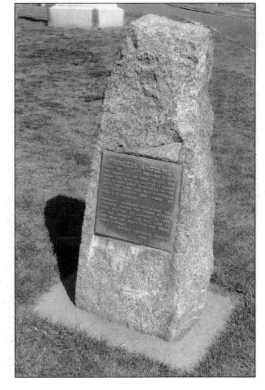

PRINCESS ANGELINE MEMORIAL. Angeline's memorial reads as follows: "Born – 1811, Died – May 31, 1896. The daughter of Chief Sealth, for whom the city of Seattle is named, was a life long supporter of the white settlers. [Born Kakiisimla,] she was converted to Christianity and named by Mrs. D. S. Maynard. Princess Angeline befriended the pioneers during the Indian attack upon Seattle on January 26, 1856." (Courtesy Cherian Thomas Photography.)

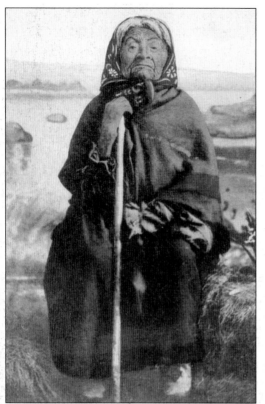

PRINCESS ANGELINE. A prominent Native American figure in Seattle's history, her original name was Kakiisimla. Angeline lived her life on the shores of Puget Sound. She was married first to Chief Dokubkun and second to Chief Talisha, both from the Duwampish tribe. Angeline had two daughters. Mamie (Mary) married William Deshaw, and Chewatum (Betsy) married Bad Joe Foster. Angeline was also known as Kickisomlo-Cud but was renamed in 1852 to Princess Angeline by Catherine Maynard, who said, "You are far too handsome a woman to carry a name like that. I hereby christen you 'Angeline.' " Wearing her famous red shawl, she was buried in a coffin that was shaped like a canoe. Angeline is said to haunt Pike Place Market, pictured below. (Courtesy Seattle Municipal Archives, No. 10391.)

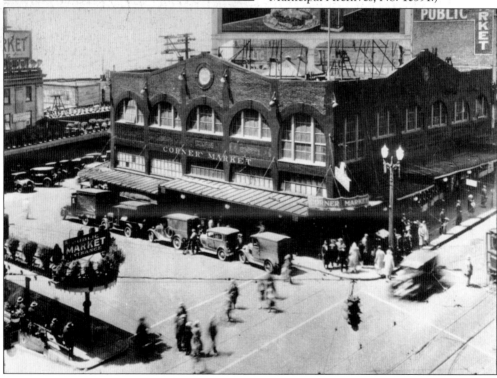

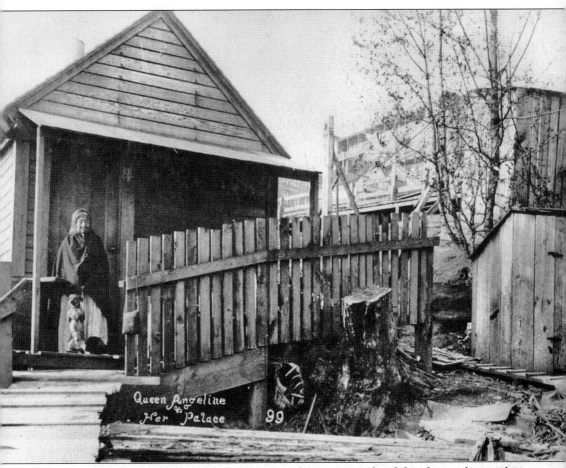

Queen Angeline
& Her Palace 99

PRINCESS ANGELINE'S WATERFRONT PALACE. Angeline is pictured with her dog on the wooden portico of her house, built in 1881 on Pike Street. In her last days, her grandson Joe took care of her. While working as a washerwoman for the white settlers, she lived her last 10 years in an old shack built by Henry Yesler near Pike Place Market. Souvenir trinkets were sold with her photographs. (Courtesy of Seattle Public Library, No. 22898.)

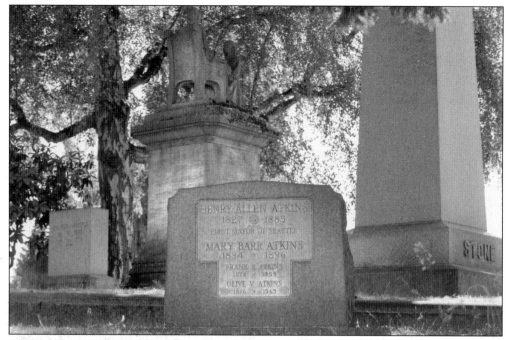

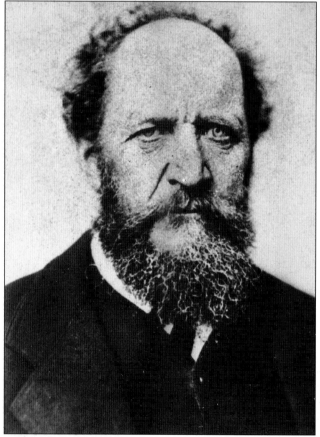

ATKINS GRAVE SITE. Henry A. Atkins (1827–1885) arrived in Seattle in 1860. Along with two partners, he owned and operated a steam-driven pile driver that helped build docks and wharves up and down Puget Sound. (Circle K.)

MAYOR HENRY A. ATKINS. Atkins, a Republican, was the first mayor of Seattle in 1865 when the city was incorporated the first time. In 1877, Henry Yesler brought suit against the city, saying there had been no right to incorporate a city in the territory. Seattle was unincorporated in 1877. (Courtesy Seattle Municipal Archives, No. 12252.)

RICHARD ACHILLES BALLINGER MONUMENT. Ballinger (1858–1922) was born in Boonesboro, Iowa, and graduated in 1884 from Williams College. He was a lawyer and judge of the Superior Court of Washington in 1894. In 1904, he was elected mayor of Seattle. (Lot 31.)

RICHARD ACHILLES BALLINGER. In 1909, Ballinger was appointed secretary of the interior under Pres. William Taft. During that time, he was accused of having interfered with an investigation into the legality of private coal–land claims in Alaska. He was later exonerated. In March 1911, he resigned. The scandal helped to turn the election of 1912 against Taft, and it split the Republican party. (Courtesy Seattle Municipal Archives, No. 12275.)

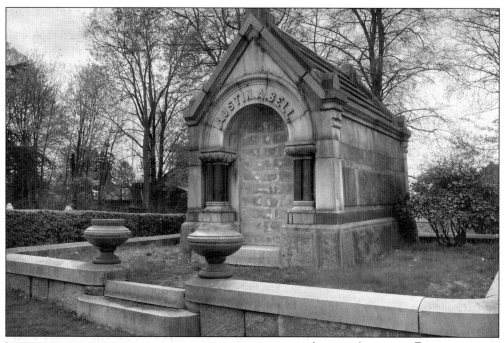

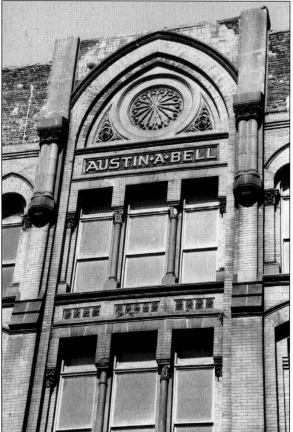

AUSTIN AMERICUS BELL MAUSOLEUM. The Bell Victorian Mausoleum had to be bricked over because of vandalism. Austin Americus Bell was born in Belltown to William and Sarah Bell. During the Battle of Seattle, the family's house was burned to the ground and they fled to California. In 1875, the Bells returned to Seattle. In 1887, William Bell (senior) died from an unidentified and strange malady. (Courtesy Cherian Thomas Photography, Lot 540.)

AUSTIN A. BELL BUILDING. One day, Bell told his son about his dream to construct a building next to their Seattle residence. The next day, he died from a self-inflicted gunshot wound to the head. In 1889, Bell's wife, Eva, built the Austin A. Bell Hotel using red bricks shipped in from San Francisco. It is located on First Avenue, a half-block north of Bell Street, adjacent to what is now the Belltown Pub. (Courtesy Seattle Municipal Archives, No. 57720.)

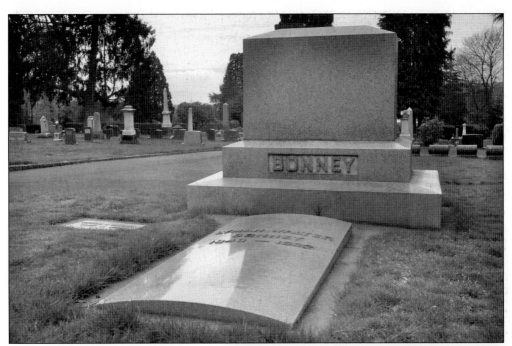

LYMAN WALTER BONNEY GRAVE (1843–1922). Bonney was reported to be a good-natured fellow and was buried toe to toe with his partner Harry Watson. Bonney came from Iowa in 1852 across the Oregon Trail to Seattle. He bought into the undertaking business with Oliver Shorey. His daughters were the beautiful Bonney girls; one married Shorey, and another married druggist Gardner Kellogg. (Courtesy Cherian Thomas Photography, Lot 364.)

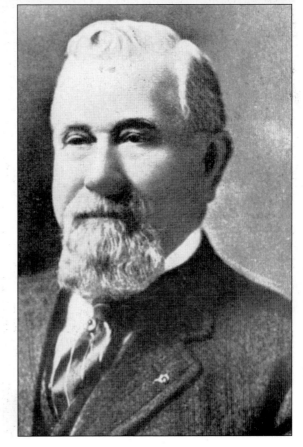

LYMAN WALTER BONNEY. Bonney was a member of the Bonney-Watson Company, funeral directors, and he spent most of his life on the Pacific coast. His undertaking establishment had the distinction of being the finest and best equipped in the United States. There was a modern crematory and columbarium, as well as a private ambulance service, all under one roof. (Courtesy Clarence Bagley.)

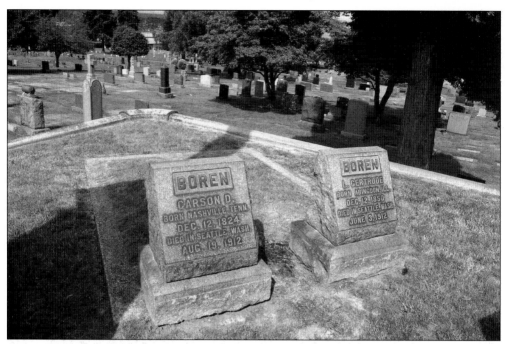

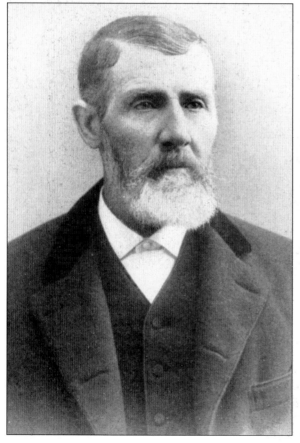

CARSON DOBBINS BOREN GRAVE (1824–1912). Behind the striking Denny plot is the plain grave site of Boren. In the summer of 1881, Boren and his wife, Mary, and daughter Gertrude traveled the Oregon Trail with the Denny-Boren party to arrive at Alki. After the winter, Boren, Denny, and Bell each laid claim to the 320 acres permitted to a married couple. Their claims were located across from Alki on Elliott Bay, which is now Seattle. (Lot 342.)

CARSON DOBBINS BOREN. Born in 1824 in Nashville, Tennessee, Boren brought with him to Seattle his building and hunting skills. Later he was named King County's first sheriff to keep the peace between the Native Americans and the settlers. Around 1855, Boren, Charles Plummer, Dexter Horton, and others went on an expedition over Snoqualmie Falls Pass, searching for future railroad routes. (Courtesy Clarence Bagley.)

MONUMENT ERECTED TO MARK GRAVE OF FAITHFUL SADDLE HORSE.

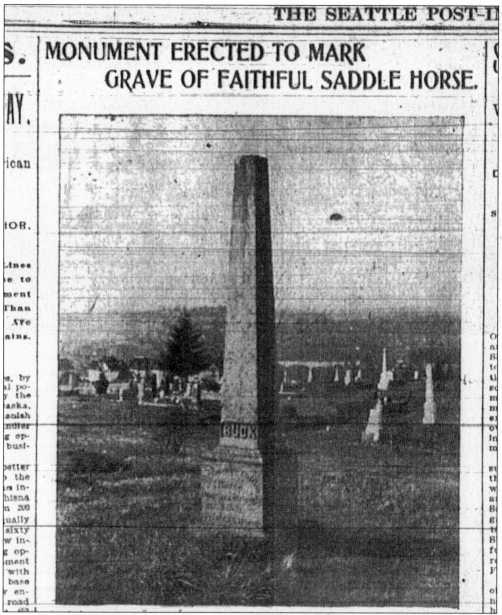

BUCK, FAITHFUL SADDLE HORSE MONUMENT. Buck was buried at Lake View Cemetery. Buck's owner, Irving Wadleigh, who erected the monument, was well known among Seattle's pioneers. A March 31, 1901, a newspaper article reported the following: "On one of the highest spots in Lake View Cemetery stands the granite shaft which is shown in the accompanying half-tone cut. It was erected by a grateful man to mark the resting place of a true friend." Engraved on the monument was, "BUCK, My Favorite Cattle Horse, Died September 20th, 1884 Aged 18 Years and 6 Months." Engraved on the eastern side of the monument is this inscription: "For 13 years my trusty companion in blackness of night, in storm, sunshine and danger." On the north side were the words, "Corniced In Adversity Faithful." Wadleigh and Buck were constant companions for 12 years at his cattle ranch in Eastern Washington. Buck was later removed from Lake View Cemetery. (Courtesy *Seattle Post-Intelligencer.*)

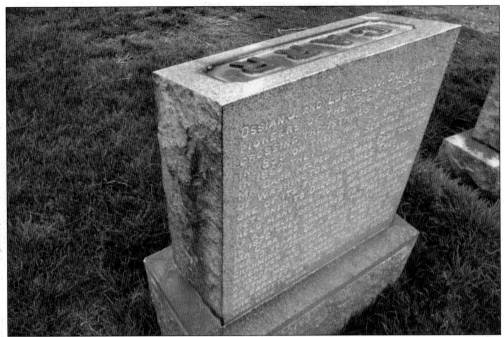

CARR MONUMENT. Ossian Carr (1832–1912) and his wife came to Seattle in 1852. For the Territorial University, Carr carved the fluted Ionic columns that currently stand at the University of Washington. In 1862, when the Territory University first opened, Mrs. Carr taught elementary school. (Courtesy Cherian Thomas Photography, Lot 420.)

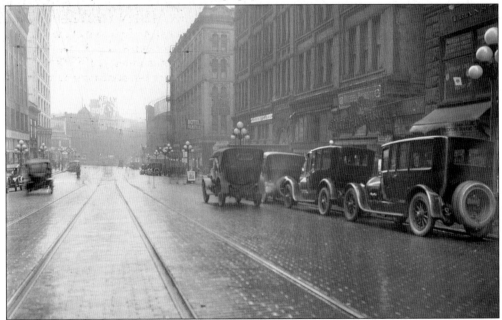

BUTLER HOTEL. Hillory Butler built the Butler Hotel, located in Pioneer Square. This photograph shows the hotel on December 13, 1920, with the Butler block visible. Hotel Butler was considered the city's classiest hotel through the 1890s. In 1860, Butler worked with the Grand Lodge of Free Masons and started a Seattle chapter. (Courtesy Seattle Municipal Archives, No. 47329.)

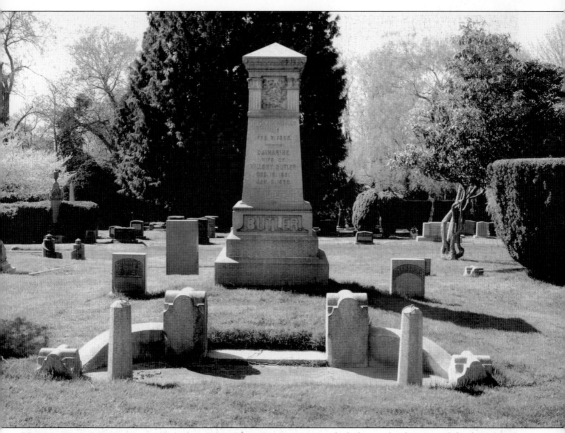

HILLORY AND CATHARINE BUTLER MONUMENT. A granite obelisk overlooks one of the best sites at Lake View Cemetery. Butler was born in Virginia. He journeyed across the Oregon Trail and arrived with the Bethel Party in 1853. During the Native American unrest of 1855–1856 Butler would race to the safety of Fort Decatur on Cherry Street and once ran in wearing his wife's red petticoat. (Courtesy Cherian Thomas Photography, Lot 147.)

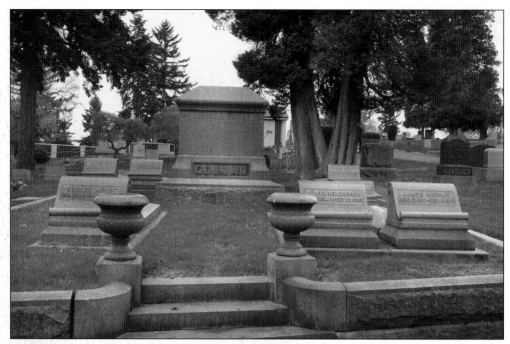

JAMES COLMAN AND FAMILY MARKERS (1832–1906). Gravestones made of red granite cover the Colman family in this plot. Pier 52 is a well-known tourist area in Seattle and used to be named the Colman Dock. James Colman is also known for building the Colman building on First Avenue. (Courtesy Cherian Thomas Photography, Lot 459.)

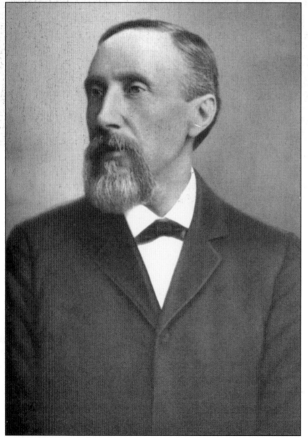

JAMES COLMAN. In 1861, Coleman arrived in Seattle and bought William Renton's sawmill in Port Orchard. Leasing Henry Yesler's sawmill in 1872, he turned it into a 24-hour operation. He helped with finishing the Seattle and Walla Walla Railroad. (Courtesy Clarence Bagley.)

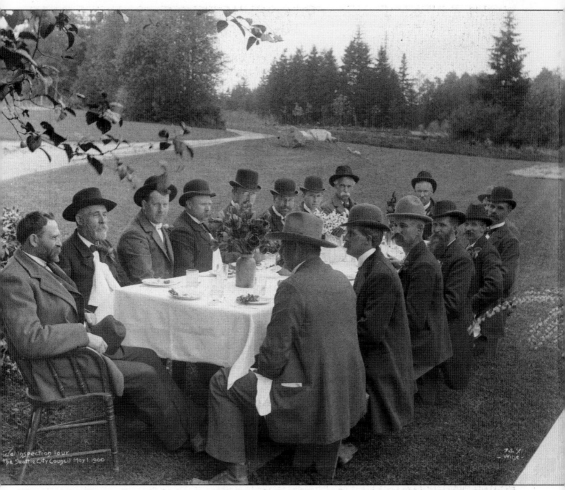

VOLUNTEER PARK. Pictured May 1, 1900, Seattle City Council members are having lunch on an official inspection tour in Volunteer Park. Colman sold 40 acres of land to Seattle for $2,000. In 1885, this land was used as a cemetery named Washelli. In 1893, the graves were removed and the land was designated as Lake View Park. (Courtesy Seattle Municipal Archives, No. 7337.)

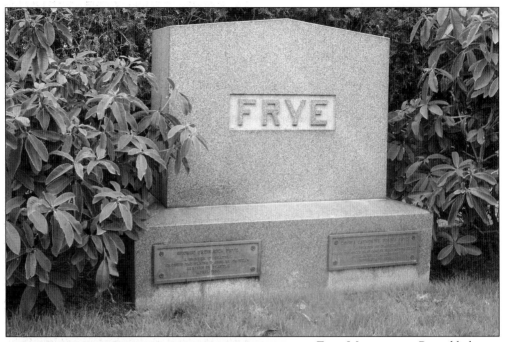

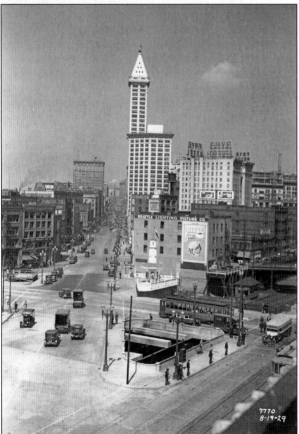

FRYE MONUMENT. Buried below this monument are Charles Frye; his wife, Catherine; their children, including Roberta Frye Watt, who wrote *The Story of Seattle*, and Sophie Frye Bass, who wrote *Pig-Tail Days in Old Seattle*; George Fortson; and Virgil Bogue. Fortson and Bogue married into the family. (Courtesy Cherian Thomas Photography, Lot 422.)

FRYE HOTEL. This photograph, taken August 19, 1929, is from Second Avenue South on the bridge at Jackson, facing the Frye Hotel. The hotel was 11 stories tall. Frye was also known for the Frye Opera House and Frye Museum on Seattle's First Hill. The opera house burned down in the great Seattle fire of 1889, so Frye built the Stevens Hotel. With A. A. Denny, he built the Northern Hotel. He also built the Barker Hotel. (Courtesy Seattle Municipal Archives, No. 3587.)

GEORGE FREDRICK FRYE (1833–1912).
Frye crossed the continent in 1852 with an ox team, arriving in Seattle in 1853. His first job was as a sawyer at Yesler's mill. He established the first meat market in the city and was associated with Arthur Denny and Henry Yesler in building the first sawmill and the first gristmill in the city. (Courtesy Clarence Bagley.)

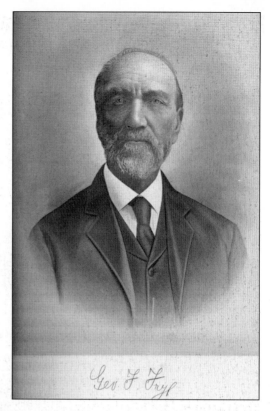

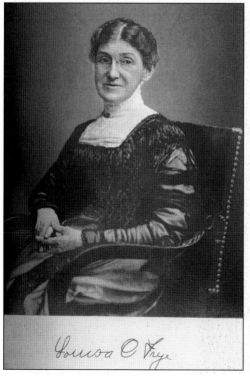

LOUISA CATHERINE DENNY FRYE (1844–1924). Louisa Frye, besides being the mother of their six children, was by her husband's side in every enterprise that he undertook and was the inspiration for much of what he accomplished. They were always together, she driving about with him from building to building and he consulting her on every decision. (Courtesy Clarence Bagley.)

ARTHUR ARMSTRONG DENNY (1822–1899). On April 10, 1851, Denny left Cherry Grove, Illinois, and traveled for 108 days on the Oregon Trail. On November 4, 1851, the Denny party arrived on the schooner *Exact* at Alki (West Seattle). Denny was a Christian, a lifelong teetotaler and political conservative, and achieved most of his wealth from real estate. Asked to sell his land, Denny replied, "But what would I do with my cow?" (Courtesy Clarence Bagley.)

MARY BOREN DENNY (1822–1910). In 1843, Arthur Denny married Mary Ann Boren in Illinois. She was the mother of his children and was the brave, staunch comrade of all his high endeavors. He attributed much of his courage through the hard years of pioneering to her uncomplaining companionship. (Courtesy Clarence Bagley.)

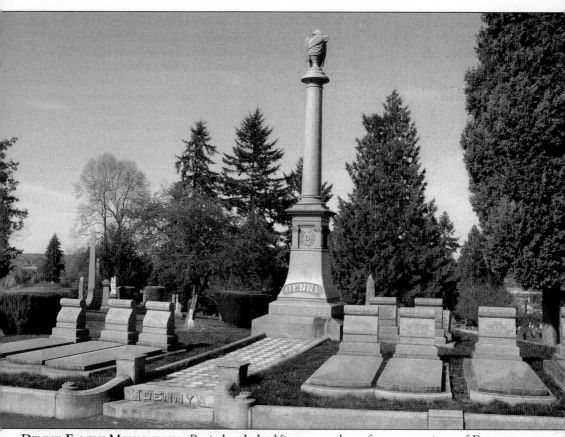

DENNY FAMILY MONUMENTS. Buried at Lake View are at least four generations of Dennys. Overlooking Seattle, this plot is one of the most spectacular, with a black and white checkered marble walkway leading up to a granite column. The individual markers are in pink granite with carved gilt lettering. The Dennys are also credited with the founding of Seattle. (Courtesy Cherian Thomas Photography, Lot 342.)

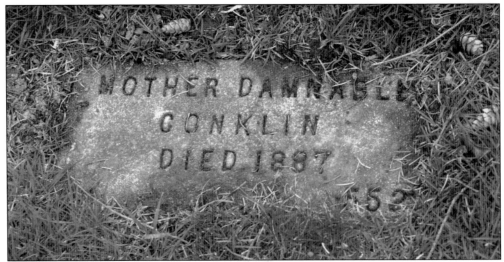

MARY ANN BOYER CONKLIN GRAVE SITE. Conklin (1821–1873) was better known as "Madame Damnable." She ran a brothel upstairs at the Felker house and was known for her scrumptious cuisine and blasphemous tongue. Conklin's first grave site was at the old Seattle Cemetery. She was buried next at the first Washelli Cemetery and then, lastly, at Lake View Cemetery. When they reburied her, they discovered that she was smiling and that her bones had turned to 1,300 pounds of stone. O. C. Shorey, the town's undertaker, points out that the gravestone incorrectly identifies the year of her death as 1887. (Courtesy Cherian Thomas Photography, Lot 552.)

FELKER HOUSE. Capt. Leonard Felker brought the house around the Horn in his ship *Franklin Adams* as a complete "house kit." It was assembled at Jackson Street and First Avenue South. Upstairs of the Southern-style mansion, Madame Damnable ran her whorehouse. After the Indian War, the city wanted to burn the brush down around the building so they could see any attackers approaching, but Damnable kept the authorities at bay with her mouth and a few mean dogs. If the brush were gone around the Felker house, passersby would be able to see her customers. She eventually gave in. (Courtesy Clarence Bagley.)

WILLIAM GUTHRIE LATIMER MONUMENT. This monument is made of black granite. Latimer was born in Tennessee and, in the spring of 1850, might have been the first white person to cross Snoqualmie Pass. It was rumored that, in the summer of 1850, he built a small hut at what is now Second Avenue and Columbia Street in downtown Seattle. In the *Seattle Post-Intelligencer*, however, he stated he had not come to Puget Sound until the fall of 1852. (Courtesy Cherian Thomas Photography, Lot 165.)

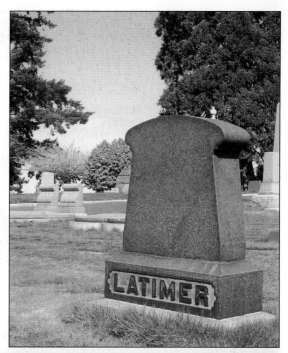

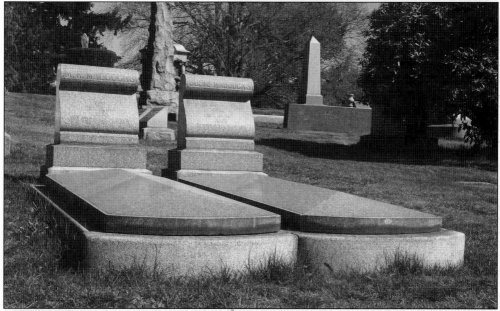

MOSES AND SUSIE MADDOCKS GRAVE SITES. Pink granite slabs cover the graves of Moses and Susie Maddocks. Moses Maddocks (1833–1919) built a grand establishment called the Occidental Hotel in 1874. He also owned a drugstore on Front Street (now First Avenue). A second Occidental Hotel was built where the first stood and was burned to the ground in the great Seattle fire of June 6, 1889. It was rebuilt again but torn down in the 1960s, and in its place was built a garage. This garage is known as the "Sinking Ship Garage" and can be seen in Seattle today at the corners of James Street, Second Avenue, and Yesler Way. (Courtesy Cherian Thomas Photography, Lot 178.)

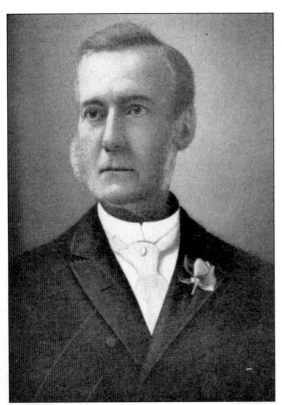

ELISHA P. FERRY (1825–1895). Ferry, a Republican, was a lawyer from Illinois. In 1869, Pres. Ulysses Grant appointed him surveyor general and he moved to Washington Territory. In 1872, Grant appointed him governor for eight years. After Washington became a state, Ferry became its first elected governor in 1889. (Courtesy Clarence Bagley, History of Seattle.)

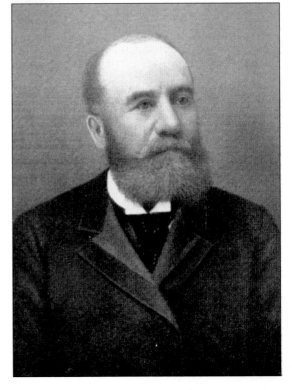

JOHN LEARY (1837–1905). A partner of Elisha Ferry, Leary arrived in Seattle in 1869 with an unusual aptitude for business and a genius for the successful creation and management of large enterprises. On July 14, 1884, voters elected the businessman as mayor of Seattle. (Courtesy Seattle Municipal Archives, No. 12264.)

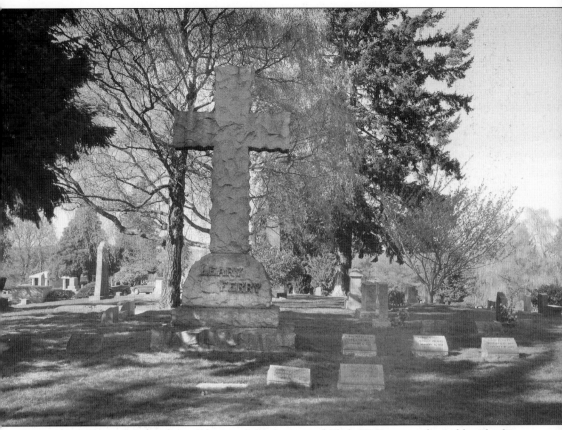

LEARY AND FERRY MONUMENT. Partners John Leary and Elisha P. Ferry are buried beside this cross. The Leary family is buried on the left of the cross, and the Ferry family plots are to the right. Not only were the two men business partners, but Leary married Ferry's oldest daughter, Eliza. (Courtesy Cherian Thomas Photography, Circle EE.)

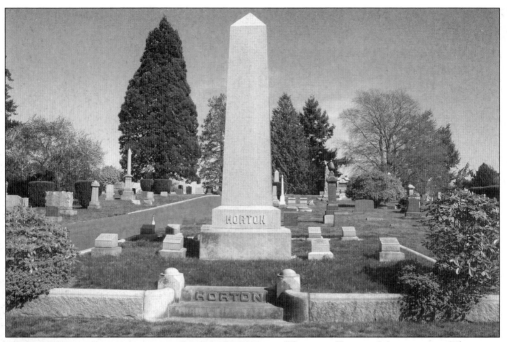

HORTON FAMILY MONUMENT. This gigantic gray granite Egyptian obelisk with a surrounding pedestal marks the burial site of Dexter Horton (1825–1904) and his wives Hannah Shroudy, Caroline E. Parsons, and Arabella C. Agard. Horton grew up in Illinois and, in 1853, crossed the Oregon Trail with the Bethel party. On a gloomy day in April 1853, Horton arrived in Seattle, broke and recovering from the "ague." (Courtesy Cherian Thomas Photography, Lot 181.)

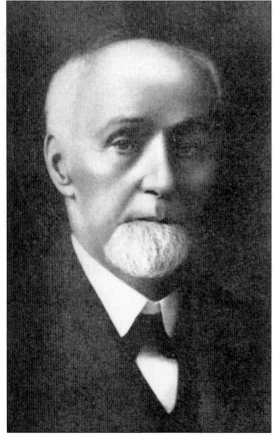

DEXTER HORTON. His first job was working to remove stumps from Bell Town for $2.50 a day. That fall, he and his wife managed the cookhouse of Renton's sawmill in Port Orchard. Returning to Seattle, he next worked at Yesler's Sawmill while his first wife, Hannah, worked at the Yesler cookhouse. They saved every penny that they could and stored it in their old wooden steamer trunk. (Courtesy Clarence Bagley.)

DEXTER HORTON BUILDING. This October 1928 photograph was taken outside of the Dexter Horton Building. In 1854, Horton owned a general store on Commercial Street (now First Avenue) with Arthur Denny and David Phillips. Horton was Seattle's first banker. Rugged loggers and seaward sailors would ask trustworthy Horton to store their money. Horton put their gold coins in a bag, tied it with their name around it, and shoved it into a coffee barrel or hid it in a safe place in the store. When the depositors returned to make a withdrawal or deposit, Horton would fish around the barrel or pull it out of its safe hiding place to complete their requested transaction, then rewrite the balance. As a result, much of the currency and coins of the day smelled like coffee. The banking business was taking off in Seattle; with $50,000 invested, the Horton and Phillips Bank was begun. The bank went through transition and several name changes, first as Seattle First National Bank, then Seafirst Bank, and now Bank of America. Horton, who is the essence of a rags-to-riches pioneer, died on July 28, 1904, in his Seattle home. (Courtesy Seattle Municipal Archives, No. 3159.)

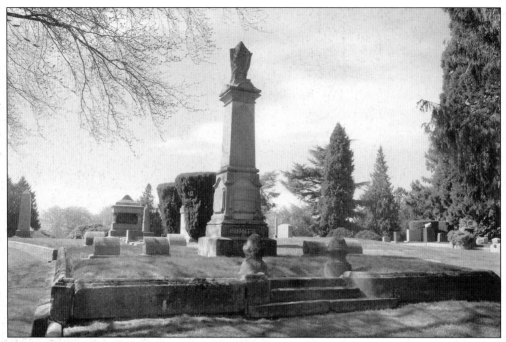

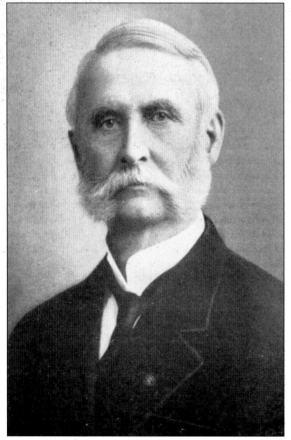

KINNEAR FAMILY MONUMENT. This Victorian monument with three rises represents the Christian tenets of faith, hope, and charity. A partially draped urn sits at the top of this grey granite column. (Courtesy Cherian Thomas Photography, Lot 169.)

GEORGE KINNEAR. Kinnear (1836–1912) served during the Civil War. Every month, he sent his pay to his mother, who saved it and gave it to him upon his return. Kinnear bought land on Queen Anne Hill in 1874. He helped build the wagon road through Snoqualmie Pass and organized the city's immigration board. (Courtesy Clarence Bagley.)

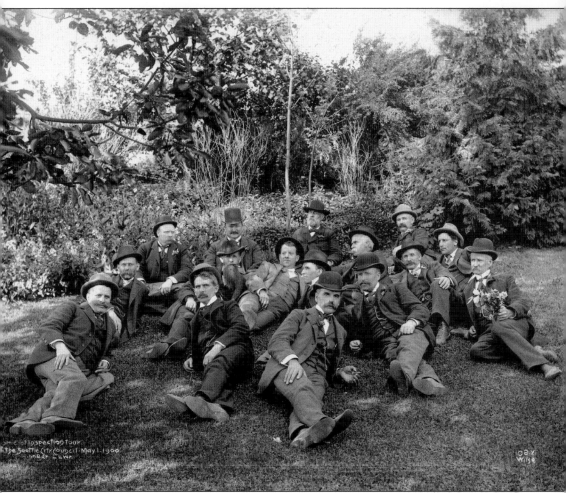

KINNEAR PARK. Taken in May 1, 1900, this image shows the Seattle City Council inspection tour on Kinnear Park lawn. For the price of $1, Kinnear sold to the city this wooded piece of land that later came to be known as Kinnear Park. Sherwood Park History files state in an Olmsted report, "Band concerts were given each Tuesday evening in the pavilion during the 1910 season and proved a boon to the [residents], the average attendance was 2690." On Sunday afternoons in 1910, and again in 1936, community meetings were held on the lawn. In 1903, an Olmsted report approved the park's development but pushed for more individuality. The 1904 report mentioned the popular lower areas for picnickers. In 1909, the report noted the presence of "swings, teeters, sand courts, etc.," for small children. (Courtesy Seattle Municipal Archives, No. 7304.)

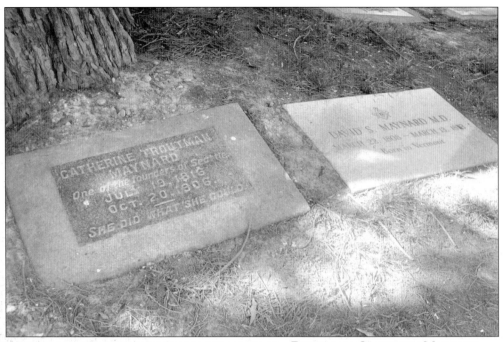

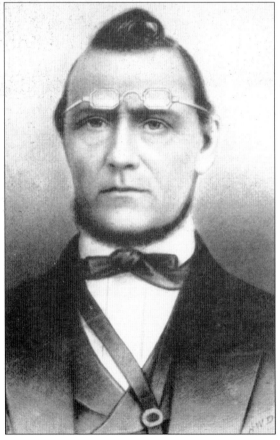

DAVID AND CATHERINE MAYNARD GRAVE SITES. At the base of a giant sequoia redwood tree are the flat gravestones of the Maynards. Thomas Prosch planted the giant redwood tree at Lake View's highest point. Dr. Maynard came over on the Oregon Trail, and during his journey he met his soon-to-be second wife, Catherine. Her epitaph reads, "She did what she could." (Courtesy Cherian Thomas Photography, Lot 211.)

DR. DAVID SWINSON MAYNARD (1808–1873). Maynard arrived in Seattle in 1852. His innovative strategy to sell salted salmon to San Francisco failed, so he started Seattle's first store, which sold general merchandise and medicine on Main Street and First Avenue. He also served as Seattle's justice of the peace and was responsible for suggesting the name Seattle, after his new Native American friend Chief Sealth. (Courtesy Clarence Bagley.)

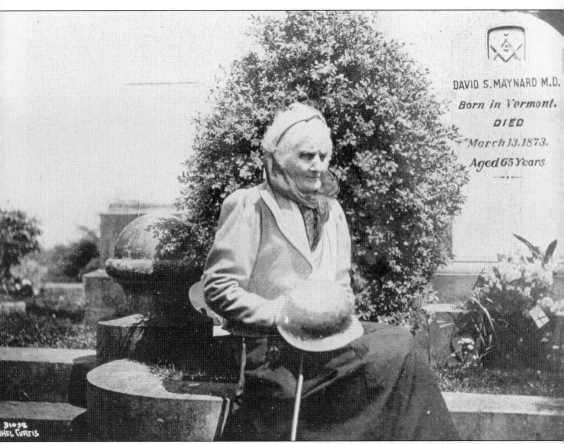

CATHERINE MAYNARD AT DOC MAYNARD'S GRAVE SITE. This famous 1906 photograph of Catherine Maynard (1816–1906) was taken by Asahel Curtis at Lake View Cemetery beside Doc Maynard's grave. Catherine risked her life to warn the settlers in Seattle of an imminent attack by Native Americans on January 25, 1856. Catherine met Doc Maynard on the Oregon Trail after her husband and several in her family died. Believing that Maynard had officially divorced his first wife, Catherine married him in 1853. In 1872, Lydia Maynard, the first wife, showed up to claim half of Doc's land. Maynard had declared his first wife dead in order to marry his second wife. Lydia lived with Doc and Catherine while she was claiming ownership of half of the original land deed, a situation that had the town raising eyebrows. (Courtesy Museum of History and Industry, No. 2741.)

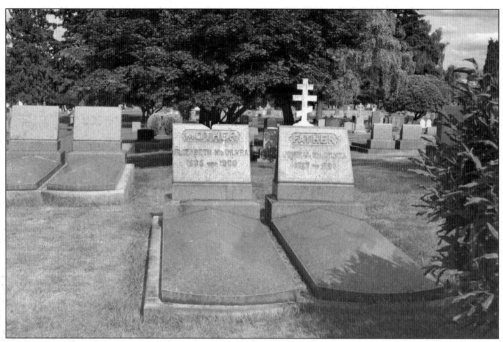

JUDGE JOHN J. McGILVRA (1827–1903). In 1864, McGilvra was appointed by Abraham Lincoln as the U.S. attorney for the Territory of Washington. He arrived in Seattle in 1867 and built a nice white house, Laurel Shade, on the shores of Lake Washington. The house was later used by the Pioneer Historical Society. (Lot 416.)

JUDGE JOHN J. McGILVRA. Before McGilvra came to Seattle, he practiced law in Illinois in association with Abraham Lincoln. In the 1860s, McGilvra purchased 420 acres of land for $5 an acre on the shores of Lake Washington. At the time, land was being sold to help finance the University of Washington. (Courtesy Clarence Bagley.)

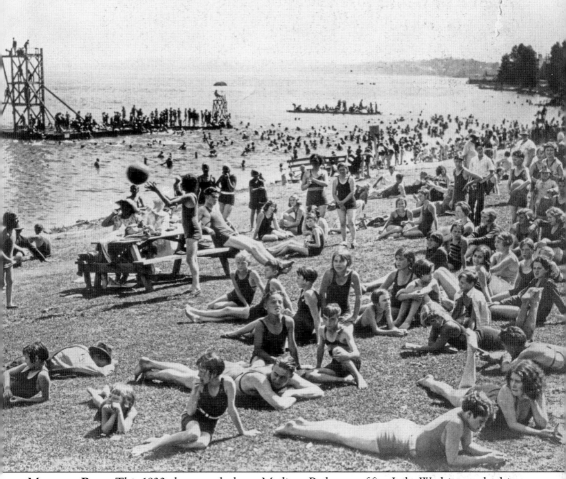

MADISON PARK. This 1930 photograph shows Madison Park, one of five Lake Washington bathing beaches. Judge John J. McGilvra created this lakeshore park, which became the most popular beach in Seattle during the late 19th century. It featured floating bandstands, a paddle wheel steamboat, a boardwalk, beer and gambling halls, athletic fields, a greenhouse, and piers for ships that cruised on Lake Washington. (Courtesy Seattle Municipal Archives, No. 29786.)

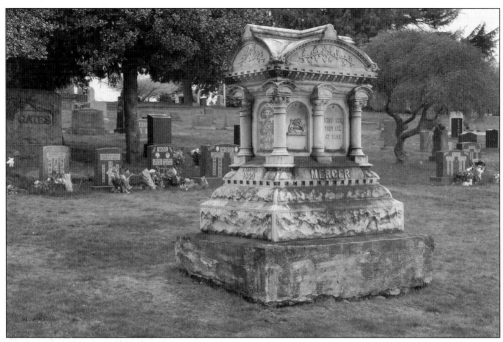

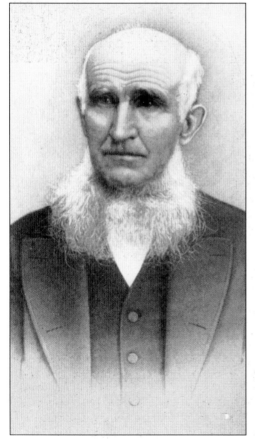

MERCER MONUMENT (1813–1898). Thomas Mercer arrived in Seattle in 1852 and made a land claim on the southwest shore of Lake Union. He had five daughters who married into pioneer families. His brother Asa was responsible for bringing in potential brides called the Mercer Girls. He held a huge Independence Day picnic in 1854 at his farm and was responsible for naming Lake Washington after the first president and Lake Union. Mercer's Island (Mercer Island) was named after him. He loved to have natives bring him to the island in a canoe so he could explore and pick berries. (Courtesy Cherian Thomas Photography, Lot 292.)

THOMAS MERCER. Mercer was born in Harrison County, Ohio, in 1813. He crossed the Oregon Trail with his wife and daughters. Mrs. Mercer took ill and died when the family reached the Cascade Mountains. Mercer Street is the dividing line between the land he claimed and the Denny claim. In 1859, he went to Oregon for the summer and married Hester L. Ward. During the Indian War, Mercer's house was spared from being burned because, "Oh, old Mercer might want it again." (Courtesy Clarence Bagley.)

MEYDENBAUER FAMILY MONUMENT. This unpretentious monument marks the grave site of one of Bellevue's foremost landowners. William Meydenbauer (1832–1906) is well known for Lake Washington's Meydenbauer Bay and Meydenbauer Park. He was also the third owner of Eureka Bakery in 1871. (Courtesy Cherian Thomas Photography, Lot 218.)

OSBORNE MONUMENT (1834–1881). Under a huge column of Carrara marble that dissolves in the Pacific Northwest dampness lies James Osborne, who was proprietor of the famous Gem Saloon. Because of its wild reputation, the establishment was given the title "Sin City" on Puget Sound. He willed his estate to the City of Seattle for the construction of an opera house, which was later named the Seattle Opera House. (Courtesy Cherian Thomas Photography, Lot 197.)

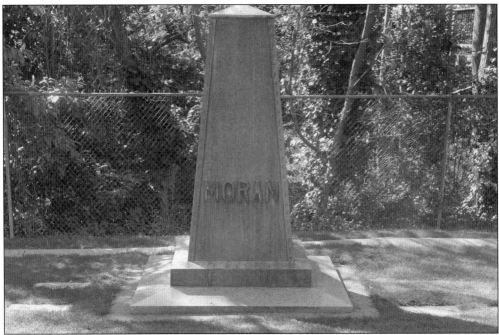

MORAN FAMILY MONUMENT AND PLOT. This very impressive monument was designed by Moran and built out of riveted sheets of bronze welded together to resemble a ship's hull. The Morans got their wealth from shipbuilding. This Egyptian obelisk sits on huge plots (lots 1147–1149) and is the largest family site at Lake View Cemetery. (Courtesy Cherian Thomas Photography.)

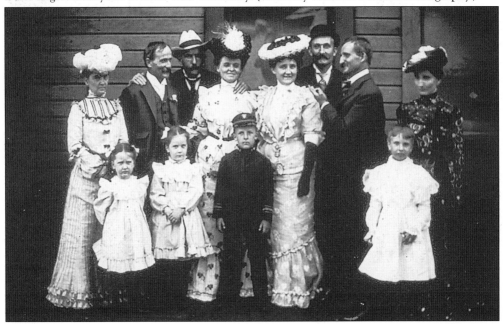

MORAN BROTHERS WITH FAMILY. The Moran brothers pose around 1903 with their wives and children on Sunday after church at the shipyards. Moran Brothers Company meetings at the shipyard often were a family affair. The family corporation kept all of their stock within the family. (Courtesy Rosario Resort.)

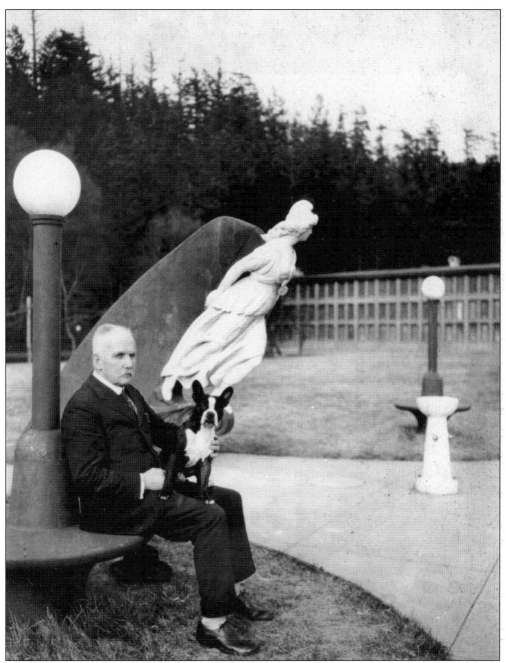

ROBERT MORAN WITH KENO. Robert Moran (1857–1943) was born in New York City, the grandson of an Irish immigrant who came to America in 1826. In November 1875, at the age of 17 years, he was on a steerage ticket and landed at Yesler Dock. Upon arriving, he charged his first breakfast at a local hash house. In a July 4, 1937, letter to the *Seattle Times*, he wrote, "Thirty-one years ago I left the shipbuilding business in Seattle. I was a nervous wreck. The doctors had me ticketed for Lake View Cemetery—due, as they said then, to organic heart disease. Doctors in those days were not as well informed as they are now on the ills of the human body." (Courtesy Rosario Resort.)

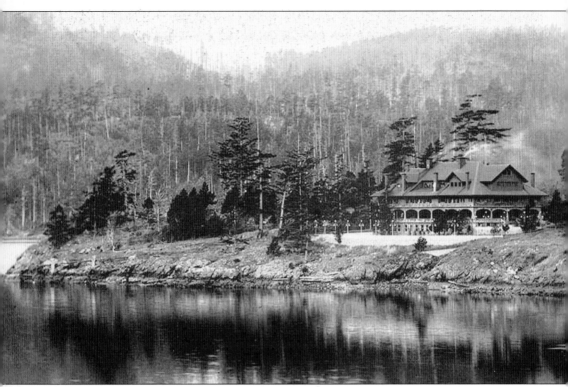

ROSARIO RESORT. Previously called the Moran Mansion, the Rosario Resort, in the San Juans, has five floors and a total of 54 rooms, including 18 bedrooms. Moran designed and built the maroon mansion and his own direct-current hydroelectric power system. An indoor saltwater swimming pool and recreation room—including a pool table, billiard table, and a two-lane bowling alley—were located on the 6,600-square-foot lower level on floors made of Italian mosaic tile. At 7:00 a.m. sharp in the music room balcony, Moran would wake the house playing the pipe organ. One of his favorite songs was "Work, for the Night is Coming." The mansion, including all of the furnishings and outbuildings on 1,338 acres, was sold in 1938 to a Californian named Donald Rheem for $50,000. Rheem's wife was quite a character and played poker with the boys in town while wearing a flaming red nightgown. After the game, she would jump on her motorcycle and ride back to the mansion. Her ghost still makes an appearance at Rosario Resort. (Courtesy Rosario Resort.)

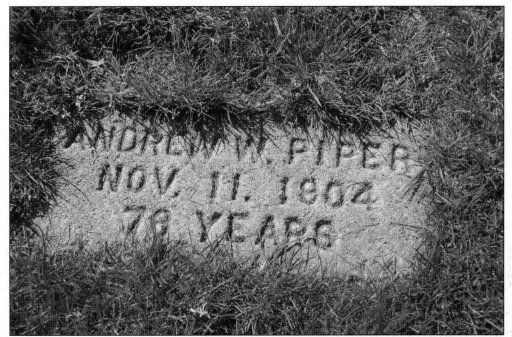

PIPER GRAVE. Andrew W. Piper (1828–1904), who was famous locally for "Piper's Dream Cakes," took his recipe to the grave. The U.S. government took Piper's property on Lake Washington for the Sand Point Naval Station. In return, they gave him land north of Shilshole, which is now Carkeek Park. (Courtesy Cherian Thomas Photography, Lot 184.)

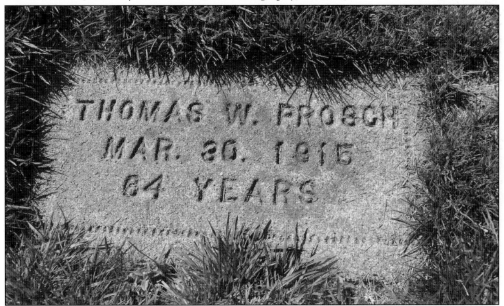

PROSCH MARKER. Thomas Prosch (1850–1915) was a prominent Seattle historian. His father, Charles Prosch, was editor of the *Puget Sound Herald* and wrote about the lack of wives for Seattle's primarily male population. The Mercer Girls were imported as a direct result of his editorial. In 1885, Prosch became editor of the *Seattle Post-Intelligencer*. He wrote several autobiographies and a detailed history of Seattle. (Courtesy Cherian Thomas Photography, Lot 164.)

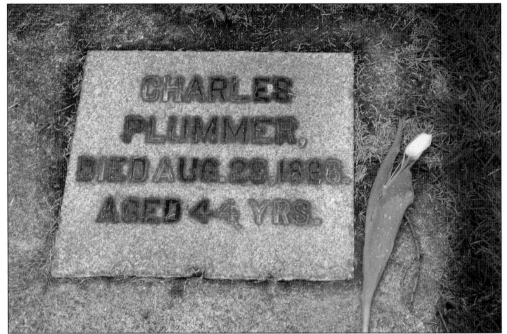

CHARLES PLUMMER (1822–1866). Plummer was buried with Masonic honors. The city's flags were half-masted, and many of the houses were draped in mourning. He ranked with Yesler, Terry, and Maynard in the early development of Seattle and its resources. (Courtesy Cherian Thomas Photography, Lot 360.)

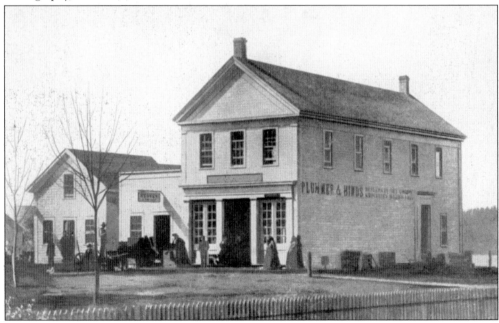

STORE OF PLUMMER AND HINDS. Taken in 1860, this photograph shows Plummer's store at First Avenue South and Main Street. Plummer's name is linked with all of its early advancement. His store was one of the largest; he had his own wharf and independent waterworks to supply it with water. (Courtesy Clarence Bagley.)

PONTIUS FAMILY GRAVES. In a roundabout way, Rezin W. Pontius built Seattle into what it is today. Seattle in the 1880s was built almost entirely out of wood, including the timber-planked streets. After the fire, Arthur Denny and Doc Maynard's contradictory street plats could at once be redesigned. With the streets raised, the city's sewers did not drain backwards with the tides as they previously did. (Courtesy Cherian Thomas Photography, Lot 175.)

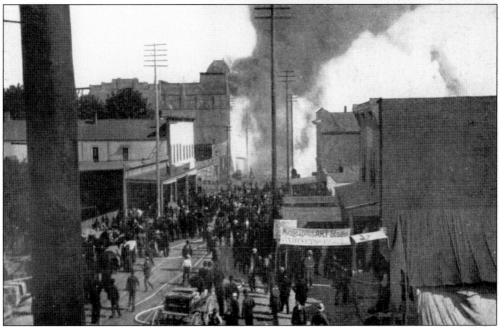

GREAT SEATTLE FIRE. Taken on June 6, 1889, this photograph shows the beginning of the great Seattle fire, which was caused by an overturned glue pot in the basement of the Pontius Building. All the buildings south of Spring Street and west of Third Avenue were burned to the ground in one day, giving way to a brand new beginning. (Courtesy Clarence Bagley.)

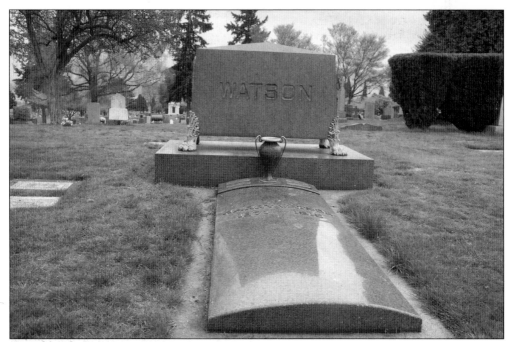

HARRY WATSON GRAVE SITE (1871–1915). Watson's grave is a solid grey granite slab that rests on four bronze lion's feet. At Watson's feet is buried his partner Lyman Bonney. Eventually the undertaking business of Shorey and Bonney was sold completely to Bonney, who became partners with Watson to form the Bonney-Watson Company. (Courtesy Cherian Thomas Photography.)

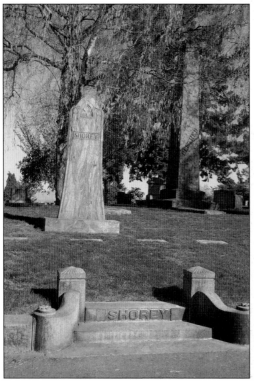

SHOREY FAMILY BURIAL PLOT. This massive granite stele of pre-Christian Rome marks the Shorey family plot. Oliver C. Shorey (1831–1900) was respected and honored in the community, and the sterling worth of his character was attested to by all with whom he came in contact. He married Mary Bonney in 1860, and the next year he carved Doric capitals on the soon-to-be university that the Reverend Bagley had notoriously schemed to build, even though there were no students to attend. With the earnings, Shorey opened a cabinet shop at the corner of Cherry Street and Third Avenue. There he made cabinets, furniture, steering wheels for steamboats, billiard tables, and other similar pieces. At that time, it was customary for the cabinetmakers to also build coffins. He eventually started the first undertaking business in Seattle, called O. C. Shorey Undertaking Company. (Courtesy Cherian Thomas Photography, Circle M.)

TERRY MONUMENT. Charles C. Terry (1830–1866), Mary Russell Terry, and their family were reburied beneath a 10-foot-tall white Carrara marble obelisk. Charles was recognized as one of the most honorable men and valued citizens that Seattle had ever known. At one time, Terry owned all of New York Alki (in Chinook, "by and by" or "in the future"). In 1855, Terry bought half of Carson Boren's land for $500 and traded his loyalty to Seattle. After the Native American attack of 1857, he traded his settlement for 320 acres from Doc Maynard. At that time, he was Seattle's largest land baron. In 1856, he bought the Bettman Brothers General Store and opened the Eureka Bakery, which made several pioneers rich, such as Meydenbauer. Tuberculosis killed him at a young 36 years. (Courtesy Cherian Thomas Photography, Lot 322.)

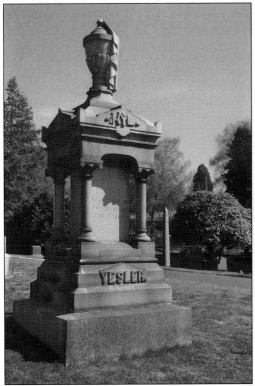

HENRY AND SARA YESLER MONUMENT. The Yesler monument was a stock mail-order item and was intended to overlook Henry (1807–1892) and his two wives. Sara Yesler is buried here, but Yesler's second wife, Minnie Gagle (who was also his second cousin), declined to be buried there. The third grave site is empty. (Courtesy Cherian Thomas Photography, Lot 111.)

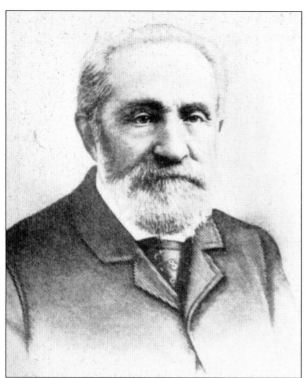

HENRY YESLER (1807–1892).
Yesler was Seattle's first
millionaire. In October 1852,
he arrived in Seattle and built a
steam-powered sawmill on Elliott
Bay. This sawmill was built at
the end of Mill Road (now Yesler
Way), famously known as Skid
Road for the way the logs skidded
down the steep hillside. He also
owned Yesler's Cookhouse, Yesler's
Wharf, and built the city's first
water system. The King County
Courthouse now occupies the spot
where his once-great mansion
stood before it was burned down
in the great Seattle fire. (Courtesy
Clarence Bagley.)

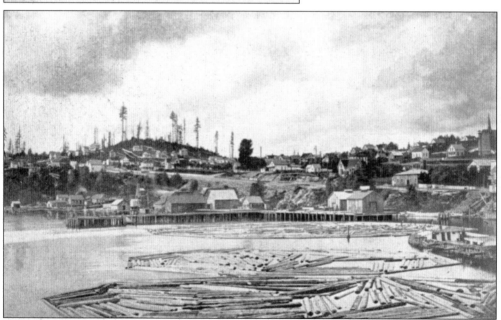

HENRY YESLER'S WHARF. This *c.* 1885 photograph shows that Yesler's Wharf was the site of
Seattle's first steam-powered sawmill, built by Yesler in 1852. The machinery arrived from San
Francisco before it had a roofed area to cover it. The mill began cutting lumber in March 1853,
with a crew composed of Native Americans and white men, many of the latter during the later
years rising to positions of wealth and influence in the affairs of the city and state. George F. Frye
was the head sawyer. (Courtesy of Clarence Bagley.)

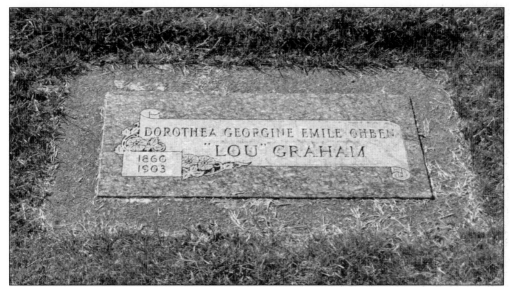

LOU GRAHAM MARKER (1860–1903). Dorothea Georgine Emile Ohben, whose stage name was Lou Graham, arrived in Seattle in 1888 on the steamer *Pacific Pride*. She bought and operated a parlor house (whorehouse) on Third Avenue and Washington Street. It was just down from city hall and was reputed to be frequented by Seattle's elite. She made a fortune and invested in real estate, only to die at the age of 42 from syphilis. Purportedly she left her riches to family in Germany, not to King County Public Schools. Graham is buried in a less prominent section chosen by her executor; away from her clientele on the hill. (Lot 926.)

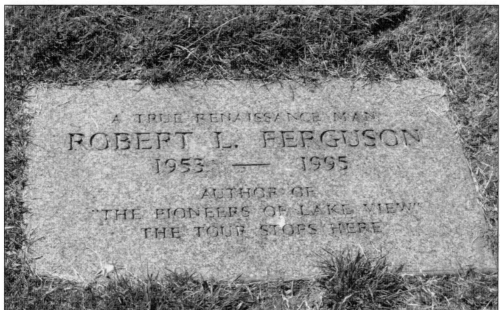

ROBERT L. FERGUSON (1953–1995). Ferguson's epitaph states, "The Tour Stops Here." He wrote *The Pioneers of Lake View: A Guide to Seattle's Early Settlers and Their Cemetery*, printed in 1995. The book is not about dead people and death so much as it is about life and how our pioneers of the Northwest lived it. The last entry in his book is the grave of the infamous Lou Graham. His grave is next to hers now, making it the last stop on the tour.

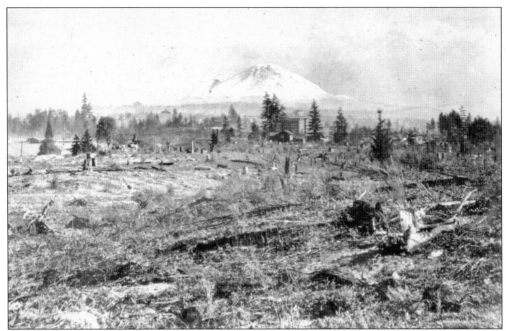

UNDEVELOPED LAND, NORTH TRUNK HIGHWAY. Mount Rainier was clearly visible from the west side of the once-dirt North Trunk Highway (now called Aurora Avenue) in 1921. Before the Aurora Bridge existed, this undeveloped property was supposed to be a housing development, but no one wanted to drive his or her automobile such a long way from Seattle. (Courtesy Evergreen-Washelli Cemetery.)

DEDICATION OF EVERGREEN CEMETERY, C. 1922. A huge gathering at Evergreen Cemetery is pictured around 1922. Note that the dirt road that was once on undeveloped land on the North Trunk Highway is now the populated Aurora Avenue. (Courtesy Evergreen-Washelli Cemetery.)

Two

EVERGREEN-WASHELLI CEMETERY

Evergreen Cemetery and Washelli Cemetery were at one time two separate entities. Headed north on the North Trunk Highway, Evergreen Cemetery was on the left side and Washelli Cemetery was on the right side behind the stately poplars now along Aurora Avenue.

At first, the land on the west side of North Trunk Road (Aurora Avenue) was slated to become a housing development; however, residents were not receptive to the notion of driving their automobiles over such a long distance to get to their jobs in Seattle.

While it was a full day's journey to get to Oak Lake (north of Greenlake) from Seattle and back, David Denny, who owned land by Oak Lake, decided to turn it into a cemetery for the purpose of relocating the remains of his son Jonathan from the old Seattle Cemetery. Jonathan, one of a set of twins, lived only a few hours and died in 1867. Jonathan Denny was first buried in a Seattle churchyard cemetery at Second and Columbia. Since he had to be reburied for the third time, his parents decided to place him on the family land. Thus began Oak Lake Cemetery (later Washelli) in 1884.

In 1891, David and Louisa Denny officially filed a plat of 40 acres as Oak Lake Cemetery. The dedication read, "The object . . . in laying out this tract of land as a cemetery is to furnish a burial place for those who need the same irrespective of nationality, color or previous condition of servitude, where the rich and the poor will be on an equality, where the tax gatherer and the book agent will not ply their vocation."

Denny's son Victor inherited the 40-acre tract in 1903. Victor sold the cemetery in 1914 to the American Necropolis Corporation, who renamed it to Washelli, which had been given to the City Cemetery of Seattle but had been disestablished in 1887. Mary B. Leary had suggested the name Washelli, as it was a Makah word for west wind, which is the region of the hereafter. Washelli Cemetery means the cemetery of the land of the hereafter.

In 1919, Evergreen Cemetery was started directly across from Washelli Cemetery. They competed for only a few short years until Evergreen Cemetery bought out the stately Washelli Cemetery in 1922. The deal became final in 1928.

In 1927, the Veterans Memorial Cemetery was started. It contains over 5,000 white marble headstones dating from the Civil War to Vietnam. Two cannons from the famous ship "Old Ironsides," officially known as the U.S. frigate *Constitution*, sit in protection. Moved from the Seattle center in 1998 to the Veterans Memorial Cemetery is the *Doughboy* statue, cast in 1928 by Alonzo Victor Lewis. Memorial Day services have been held in the cemetery since 1927, when thousands of people attended.

In 1972, the Evergreen-Washelli funeral home was started on the eastern side of Aurora—the Washelli side. In 1994, the office needed a larger space and moved to the west side, the Evergreen side of Aurora Avenue where it exists today.

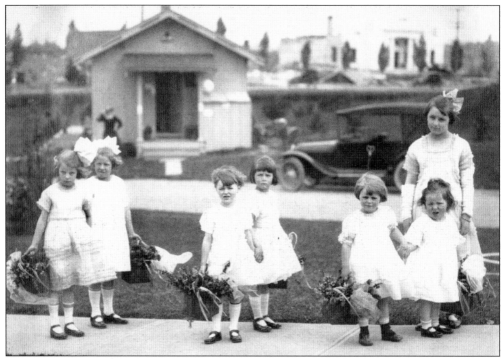

EVERGREEN OFFICE AND GATES. These photographs show an Easter celebration with a view of children in front of the old Evergreen Park office. From Evergreen, one can see the competing Washelli Cemetery across the Old North Trunk Highway. This photograph was taken sometime between 1900 and the 1920s. Perpetual care and permanent ownership were promoted at the Evergreen Cemetery. Purchasers of lots were guaranteed undisturbed "perpetual ownership. A deed was furnished for every lot, and the articles of incorporation of the cemeteries provided a perpetual care fund to care for and maintain the burial parks forever without further expense to the owners." (Courtesy Evergreen-Washelli Cemetery.)

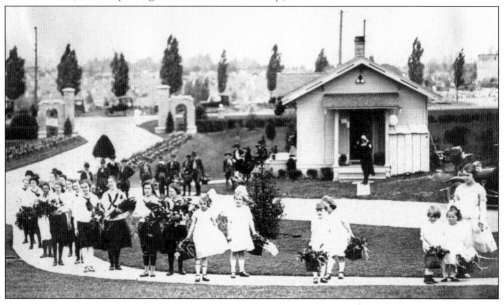

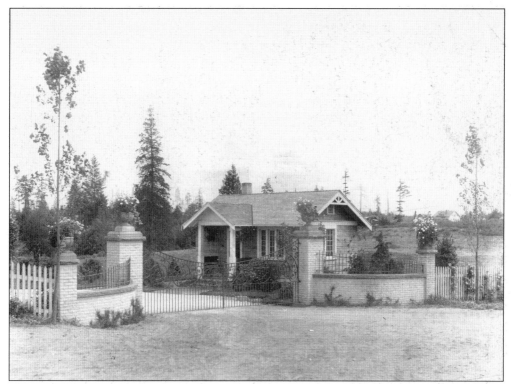

WASHELLI CEMETERY GATEHOUSE. Pictured around 1920 is the old Washelli gatehouse. Note the fine brickwork and wrought iron adorned with flowers in urn pots atop the gates. In the background on the right, old homes adorn the hillsides. (Courtesy Evergreen-Washelli Cemetery.)

PACIFIC LUTHERAN ENTRANCE. Pictured is the old Pacific Lutheran entrance, as seen from North 115th Place. The open, brick gates were located on the back side of Washelli Cemetery, at North 115th Street and Meridian Avenue North. Evergreen-Washelli now maintains this cemetery as well. (Courtesy Evergreen-Washelli Cemetery.)

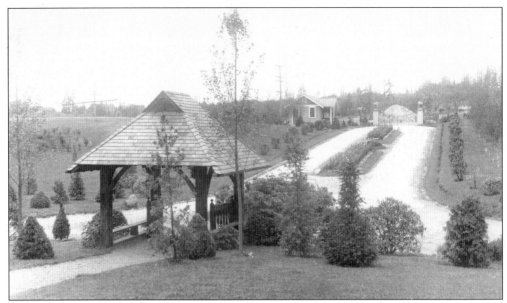

ENTRANCE TO EVERGREEN MEMORIAL PARK. Shown in 1930 is the entrance to Evergreen Memorial Park. Note the brick road, which was the North Trunk Highway (now Aurora Avenue). It was advertised as more than a beautiful park but as an institution where loved ones could be laid to rest in any manner desired—be it earth burial, mausoleum, crypt, columbarium niche, or private vault. (Courtesy Evergreen-Washelli Cemetery.)

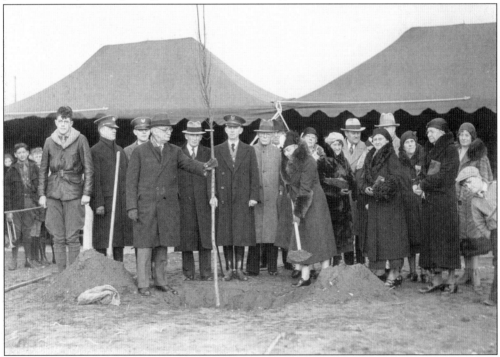

PLANTING THE FIRST POPLAR. This photograph shows the planting of the first poplar tree along Aurora Avenue. Mayor William Hickman Moore is the one holding the poplar. The other people are unidentified. (Courtesy Evergreen-Washelli Cemetery.)

BRICK ROAD, NORTH TRUNK HIGHWAY. Seen from the south along the North Trunk Highway is Washelli Cemetery's Section M. Note the brick road and the poplars growing beside the road. Visible in the center of the photograph is an elaborate grassy knoll that once spelled out "Washelli." (Courtesy Evergreen-Washelli Cemetery.)

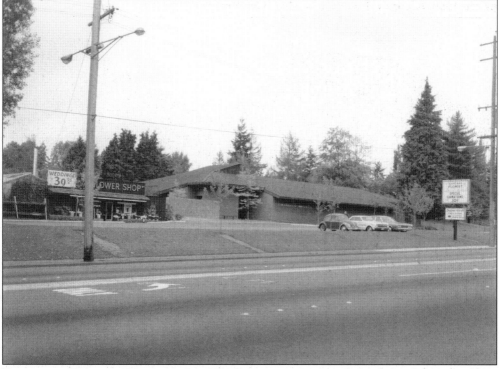

EVERGREEN-WASHELLI CEMETERY OFFICE. There was once a greenhouse behind Evergreen Park, and here you can see the flower shop next to the Evergreen-Washelli Cemetery office. (Courtesy Evergreen-Washelli Cemetery.)

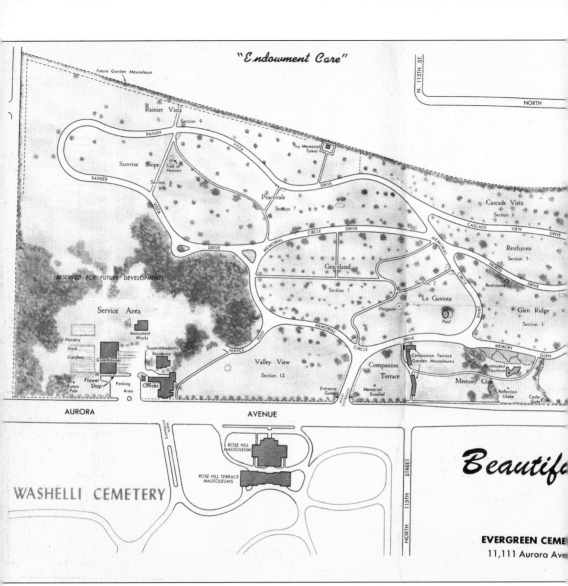

KEEPSAKE MAP OF EVERGREEN CEMETERY. This keepsake map of Evergreen Cemetery Company of Seattle showed "Where Beauty Lives . . . in flowers . . . Symbolic of immortality and love, our Flower Shop will thoughtfully place a bouquet or plant and place it at your memorial weekly or

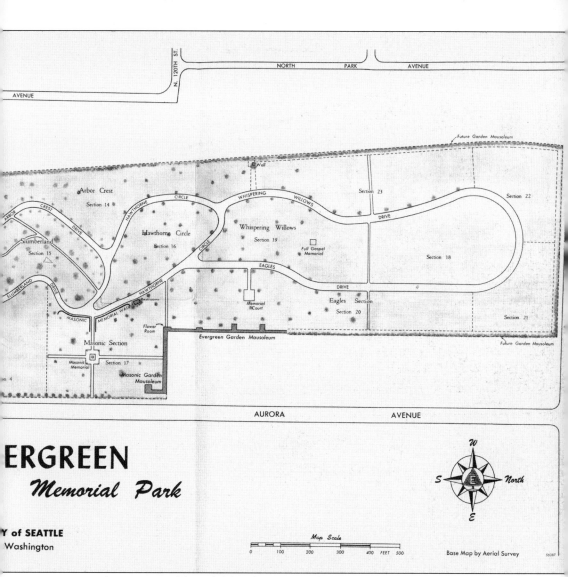

on anniversary dates . . . possibly with lilies for Easter, tulips for Memorial Day and brave holly at Christmastime." (Courtesy Evergreen-Washelli Cemetery.)

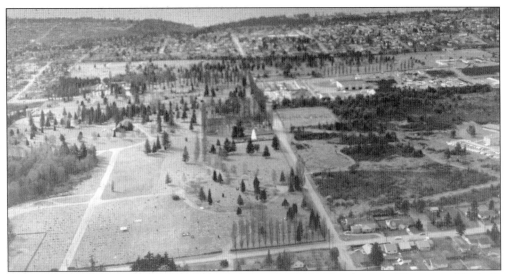

AERIAL VIEW OF EVERGREEN-WASHELLI. This mid-century aerial view of Evergreen-Washelli faces west toward Meridian Avenue North and 115th toward Puget Sound. Pictured in the center is the row of poplar trees lining Aurora Avenue. Northwest Hospital was not yet built. Below left are the Resthaven and Lutheran Cemetery sections. Just south of 115th, the white triangle Russian War Veterans Memorial is visible. (Courtesy Evergreen-Washelli Cemetery.)

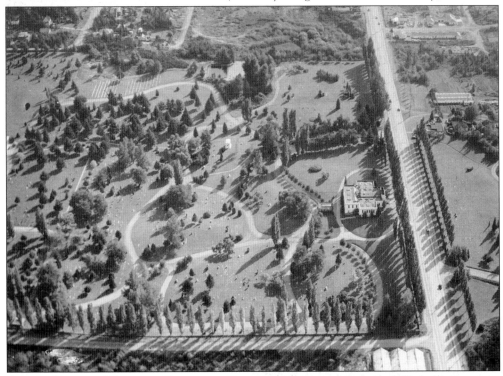

AERIAL VIEW OF WASHELLI CEMETERY. Dated 1940, this aerial view of Washelli Cemetery looks south on Aurora Avenue. Poplar trees line Aurora Avenue, with Washelli Cemetery on the left and Evergreen Cemetery on the right. (Photograph by Loren Smith Photography; courtesy Evergreen-Washelli Cemetery.)

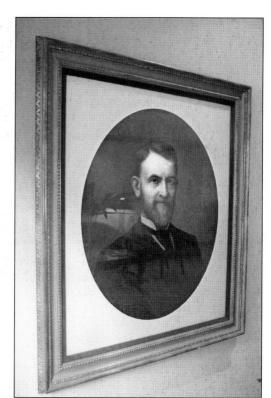

PORTRAITS OF DAVID AND LOUISA DENNY.
Hanging in the lobby of Evergreen-Washelli
Cemetery are the portraits of David and
Louisa Denny, the founders of Seattle and
Washelli Cemetery. David and Louisa were
the first couple to be married in Seattle,
and Louisa was known, for the rose seed
she carried across the plains, as the "Sweet
Briar Bride." Descendants of those roses are
planted on the Denny family lot. (Courtesy
Thomas Cherian Photography.)

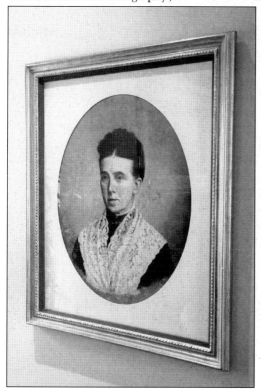

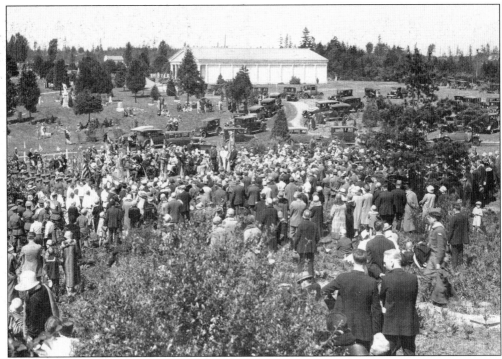

MEMORIAL DAY GATHERING AND SYMBOLIC GRAVE. In May during the late 1920s, thousands pay tribute to the nation's heroes at Washelli Cemetery, pictured above. The annual services are the center of the Northwest Memorial Day observance. Veteran organizations joined in providing a cemetery for the soldiers that died. The symbolic grave is pictured below. In the background is the Washelli mausoleum as viewed from Oak Lane. (Courtesy Evergreen-Washelli Cemetery.)

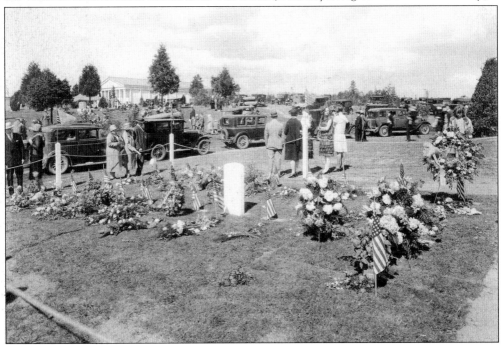

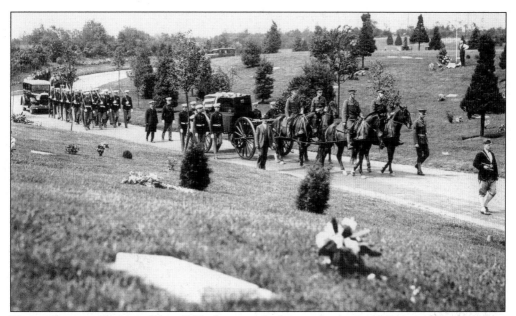

HORSE-DRAWN HEARSE. This 1909 photograph shows a horse-drawn hearse followed by an elaborate parade of mourners. Motorized hearses began to be more widely accepted in the 1920s. (Courtesy Evergreen-Washelli Cemetery.)

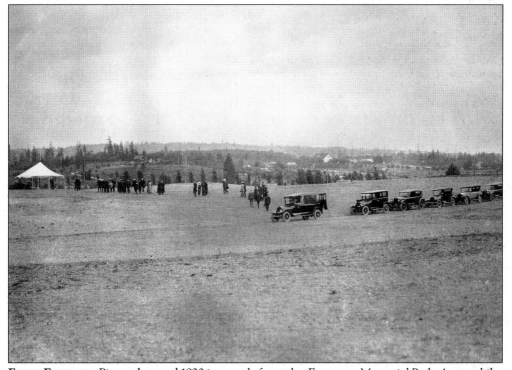

EARLY FUNERAL. Pictured around 1920 is an early funeral at Evergreen Memorial Park. Automobiles are parked along the North Trunk Highway, which was at that time a dirt road. The attendees would park and walk up the short hill to the tent and funeral service. (Courtesy Evergreen-Washelli Cemetery.)

FRED HARLEY. This *c.* 1920 photograph shows Fred Harley next to an unidentified man standing on the automobile. Behind them is the original Evergreen Cemetery office. In August 1922, Evergreen Cemetery purchased Washelli Cemetery, which included the land as well as "1 Ford truck, 1 horse, office safe and furniture supplies, etc." (Courtesy Evergreen-Washelli Cemetery.)

FUNERAL CARS AND INTERURBAN RAIL LINE. Pictured is the Descanso funeral car, similar to what ran to and from Evergreen-Washelli Cemeteries. The funeral car was elegantly furnished with a solid mahogany, polished plank-on-plank burl wood interior outfitted with plush green mohair seats for the bereaved family (wicker for the pallbearers, cigar smokers, and "lesser folk"), black and nickel-plated fittings, dark pinstriped exterior and stained-glass clerestory, and oval windows in green and blue marbleized glass. The loading doors for the casket can be seen under the oval window. The fare for mourners was 50¢ round-trip, and caskets were transported one way for $1. (Courtesy Evergreen-Washelli Cemetery.)

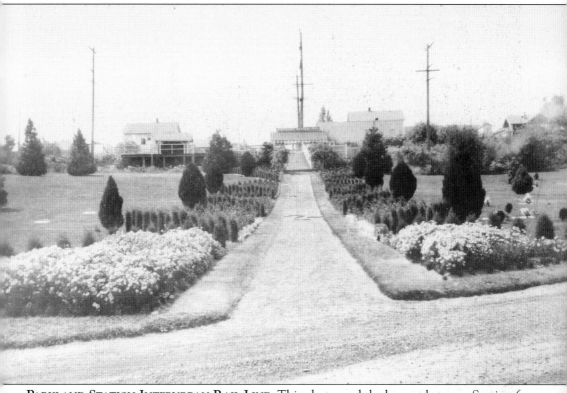

PARKLAND STATION INTERURBAN RAIL LINE. This photograph looks west between Section 6 on the left and Section 14 on the right. In the background is the platform for the interurban rail line at the Parkland Station. Before the automobile became the accepted mode of transportation, the funeral car was an everyday sight at many of the nation's major cemeteries. The funeral car ran on normal trolley tracks. Evergreen-Washelli was served by the Seattle–Everett Interurban, which traveled on the west edge of Evergreen Cemetery until the late 1930s. The turnstile that regulated foot traffic from the Oaklake Station is still at the walkway through Section 14. (Courtesy Evergreen-Washelli Cemetery.)

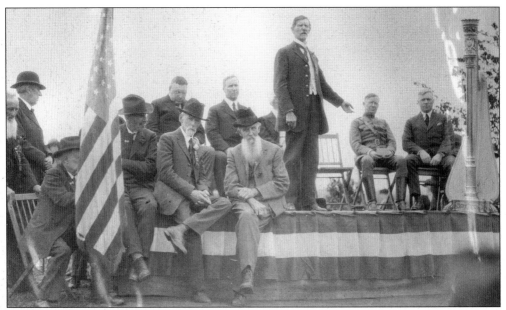

VETERANS DAY, EARLY 20TH CENTURY. Clinton S. Harley, who managed Evergreen Memorial Park, is seated on the right in the photograph above. The image below was taken on the same day. Veterans Day was established to acknowledge all of our veterans and their contributions toward protecting national security, not just those who died. In 1919, Woodrow Wilson commemorated Armistice Day in the United States. On November 11, 1918, the Allied powers signed a cease-fire agreement with Germany. The signing took place at Rethondes, France, and brought World War I to a close. The United States, France, and Great Britain set aside November 11 as Armistice Day. The holiday is recognized as a day of tribute to veterans of both world wars after World War II. (Courtesy Evergreen-Washelli Cemetery.)

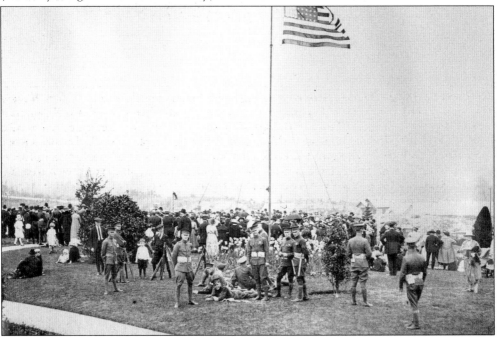

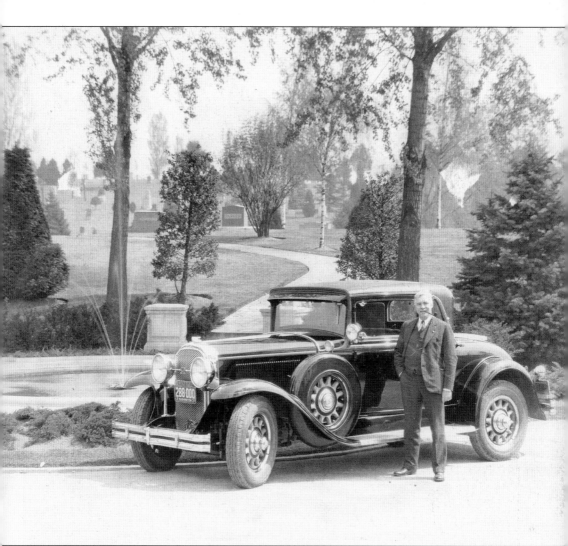

CLINTON S. HARLEY. Harley, pictured standing beside his automobile around 1930 in Washelli Cemetery, was born in Ohio in 1877 and left school at age 13 after his father's death. As a grocery delivery boy, he earned $2 a week. At the age of 16, he traveled Europe. Returning to America, Harley moved to Colorado, where he wedded Laura Potter. In Cripple Creek, he became a junior bank officer. In 1903, he relocated to Seattle on a direct invitation from Seattle pioneer Dexter Horton. With Horton, Harley helped promote the savings department, which was known as Seafirst Bank and is now known as Bank of America. Next he worked for German-American Mercantile Bank. Relocating to Alaska, he became a manager at a salmon cannery. He moved back to Seattle, where his brother Robert Harley was a founder of Evergreen Cemetery; Harley became the new general manager. He developed and ran Evergreen Cemetery for three and a half decades, shaping Evergreen-Washelli into what it is today. (Courtesy Evergreen-Washelli Cemetery.)

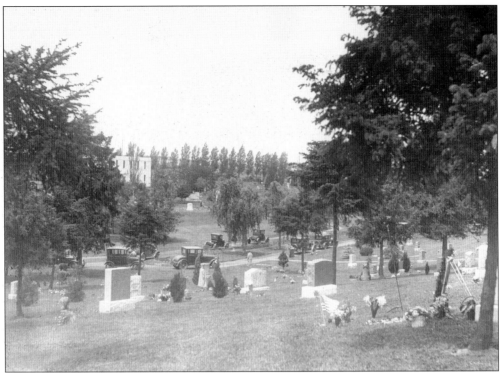

EARLY WASHELLI CEMETERY. This photograph looks northwest from Section 0 at the back of Washelli's columbarium. Notice the willow (poplars) strip in the background and Washelli Hollow in the immediate foreground. Only a short distance north of Seattle city limits on Woodland Park Avenue, they have splendid transportation facilities, both by Everett Interurban car and automobile bus. (Courtesy Evergreen-Washelli Cemetery.)

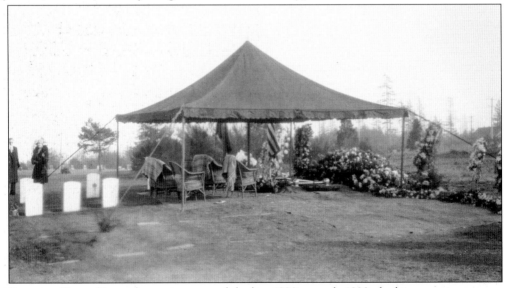

FUNERAL TENT. Pictured sometime around the late 1920s or early 1930s, looking east, is a tent set up for a funeral ceremony. This is in the Veterans Memorial Cemetery, which is part of Washelli Cemetery. (Courtesy Evergreen-Washelli Cemetery.)

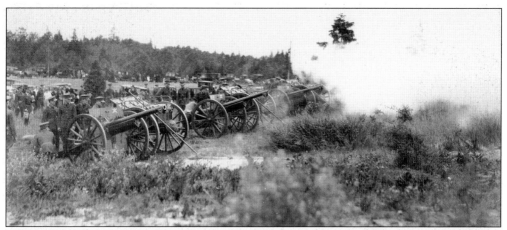

SEATTLE SALUTES HEROIC DEAD, MAY 30, 1928. Approximately 22,000 people crowded the North Trunk Highway to build a floral crest on the knoll, where 20 veterans of four wars are laid to rest in the corner of Washelli Cemetery, the "Arlington of the West." At noon, four guns of Battery F, 146th Washington Field Artillery, commanded by Capt. Pearl Roundy, sounded a solemn martial note every five seconds until the national salute of 21 guns had been fired. The afternoon ceremonies began at 2:00 p.m., with members of all veterans organizations laying wreaths on the symbolic grave bearing a government headstone with an epitaph to the "Unknown Defenders of the Nation." Judge Malcolm Douglas spoke on the noble, and Mrs. Douglas addressed the Gold Star Mothers. (Courtesy Evergreen-Washelli Cemetery.)

SECOND ANNUAL MEMORIAL DAY PROGRAM. This is the official Memorial Day program for Wednesday, May 30, 1928, at the Veterans Memorial Cemetery in Washelli Cemetery. (Courtesy Evergreen-Washelli Cemetery.)

SECOND ANNUAL

MEMORIAL DAY

Program

at the

Veterans Memorial Cemetery

WEDNESDAY, MAY 30, 1928
2:00 P. M.

In Charge of Ceremonies Major C. R. Christie
Chairman, Board of Trustees, Veterans Memorial Cemetery

All Veterans Posts and Patriotic Organizations will form in Washelli Cemetery south of the Mausoleum and march to the Veterans Memorial Cemetery headed by the Drum and Bugle Corps of University Post No. 11, American Legion.

Music Band, 146th Field Artillery, W. N. G.
Firing Squad Company C, 6th Engineers, U. S. A.

Song — "Onward Christian Soldiers" Assembly
R. H. Vivian, Song Leader

Invocation Rev. Father J. C. Camerman
Former Chaplain, 145th Machine Gun Battallion,
315th Infantry, U. S. A.

Solo — "Battle Hymn of the Republic" Marvin K. Gaukle

Address Judge Walter B. Beals
Supreme Court, State of Washington

Song — "America" ... Assembly

Placing of Wreaths on Symbolical Grave by Veteran and
Patriotic Organizations
Music by the Band

Solo — "The Star-Spangled Banner" Mrs. Bert Ross

Benediction Rev. A. E. Sorensen
Danish Lutheran Church
Former Chaplain, 329th Field Artillery, U. S. A.

Salute Company C, 6th Engineers, U. S. A.

Laments Seattle Pipe Band

Taps

A symbolic grave will be placed immediately in front of the speaker's platform where full honor and reverence to the Soldier Dead of Seattle, and to the unknown dead who are buried in France, and other fields, will be paid.

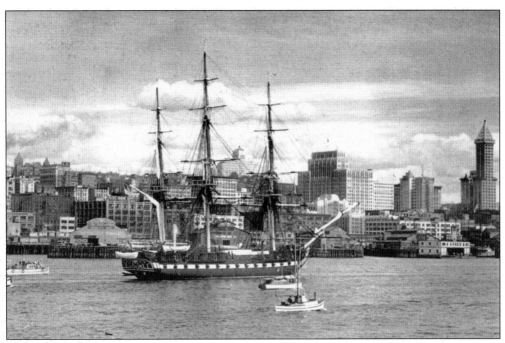

U.S. FRIGATE CONSTITUTION. Pictured May 1933 in Seattle, the U.S. frigate *Constitution*, famously known as "Old Ironsides," is traversing Elliott Bay on a world tour. The vessel was launched in 1797 at Hartt's Shipyard in Boston, Massachusetts. This gallant old ship had been restored to the condition she was in at the height of her brilliant career. (Courtesy Evergreen-Washelli Cemetery.)

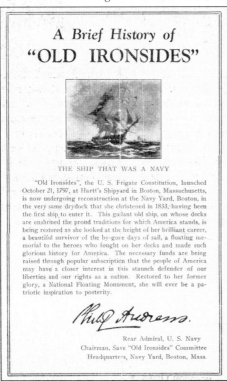

A Brief History of
"OLD IRONSIDES"

THE SHIP THAT WAS A NAVY

"Old Ironsides", the U. S. Frigate Constitution, launched October 21, 1797, at Hartt's Shipyard in Boston, Massachusetts, is now undergoing reconstruction at the Navy Yard, Boston, in the very same drydock that she christened in 1833, having been the first ship to enter it. This gallant old ship, on whose decks are enshrined the proud traditions for which America stands, is being restored as she looked at the height of her brilliant career, a beautiful survivor of the by-gone days of sail, a floating memorial to the heroes who fought on her decks and made such glorious history for America. The necessary funds are being raised through popular subscription that the people of America may have a closer interest in this staunch defender of our liberties and our rights as a nation. Restored to her former glory, a National Floating Monument, she will ever be a patriotic inspiration to posterity.

Phil Andrews.

Rear Admiral, U. S. Navy
Chairman, Save "Old Ironsides" Committee
Headquarters, Navy Yard, Boston, Mass.

BRIEF HISTORY OF "OLD IRONSIDES." Rear Admiral Phillip Andrews, U.S. Navy, signed this brief history of "the ship that was a navy." An International Maritime Heritage Award was given to the USS *Constitution*, presented to Comdr. David M. Cashman, U.S. Navy, the commanding officer, on December 17, 1987, by Pres. Ronald Reagan in the Oval Office of the White House, in Washington, D.C., to the commanding officer, Commander David M. Cashman, USN. Built in 1797, "Old Ironsides" was in the War of 1812 and is the world's oldest commissioned warship afloat. (Courtesy Evergreen-Washelli Cemetery.)

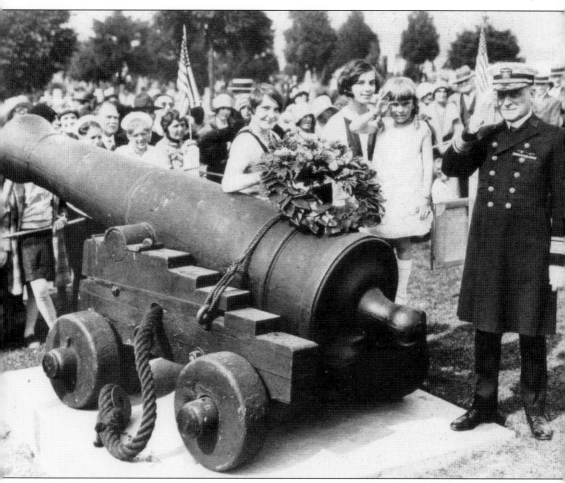

DEDICATION OF "OLD IRONSIDES" CANNONS. On Friday June 9, 1933, two 32-pound long-rifle cannons were dedicated to the "memory of those who lost their lives on 'Old Ironsides'" by the officers and men of the U.S. frigate *Constitution*, which was then in Elliott Bay, Seattle, on a nationwide tour. Rose Mary Ziegemeier, age four, was helping her father, Rear Admiral H. J. Ziegemeier, dedicate a cannon at the Veterans Memorial Cemetery at Washelli. The guns were made of cast iron and were 10 feet, 9 $\frac{1}{8}$ inches long. The maximum outside diameter was 24 inches, and they each weighed 4,275 pounds. "Old Ironsides" fought in 42 naval engagements and won them all. These were grim relics of America's first wooden navy. The guns that once echoed defiance to Great Britain now flank the walkway of the Veterans Memorial Cemetery chimes tower, silently watching over the veterans. (Courtesy Evergreen-Washelli Cemetery.)

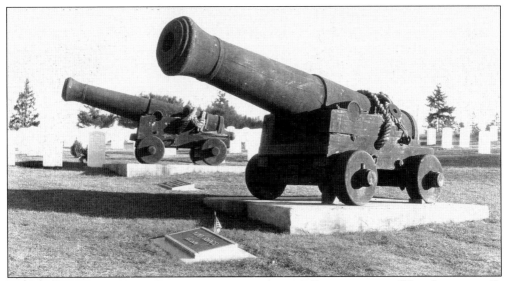

CANNONS FROM "OLD IRONSIDES." This 1942 photograph shows the original heavy ropes as the cannons were set on display at the Veterans Memorial Cemetery in Washelli. These relics of the famous U.S. Navy warship arrived on the SS *Dorothy Luckenback* to be dedicated on May 30 during the Memorial Day ceremony at the Veterans Memorial Cemetery. The cannons had been replaced from the ship, as they were not part of the original 1797 armament. (Courtesy Evergreen-Washelli Cemetery.)

THIRD ANNUAL

MEMORIAL DAY PROGRAM
Veterans Memorial Cemetery

Thursday, May 30, 1929, 2:00 P. M.

Marshal of the Day Major C. R. Christie
 Chairman, Board of Trustees, Veterans Memorial Cemetery
All Veterans Posts and Patriotic Organizations will form in Washelli Cemetery east of the Mausoleum and march to the Veterans Memorial Cemetery.

Music Band, 146th Field Artillery

Song — "Onward Christian Soldiers" Assembly
 R. H. Vivian, Song Leader

Invocation Rev. Father J. C. Camerman
 Former Chaplain, 145th Machine Gun Battalion, 315th Infantry. U. S. A.

Solo — "Battle Hymn of the Republic" Mr. Leo Radford

Address Hon. Charles P. Moriarty
 Judge, Superior Court, State of Washington
 Member Rainier Noble Post No. 1, American Legion

Solo — "The Star-Spangled Banner" Mrs. Bert C. Ross

A symbolical grave will be placed immediately in front of the speaker's platform where full honor and reverence to the Soldier Dead of Seattle, and to the unknown dead who are buried in France, and other fields will be paid.

Placing of Wreaths on Symbolical Grave by Veterans, Patriotic and Civic Organizations, Auxiliaries and Foreign Consuls of our Allies. Music by the Band.

During the ceremony flowers will be dropped over the symbolical grave by a squadron of airplanes from the United States Naval Air Station at Sand Point.

Benediction Rev. John R. Wilson, Vancouver, B. C.
 Member Fortson Thygesen Camp No. 2, U. S. W. V.

Firing Squad U. S. Marines

Taps

Music University Post No. 11 Drum and Bugle Corps

Invocation Capt. Wm. E. Gregory
 Chaplain, John Paul Jones Navy Post No. 59, American Legion

Dedication of Guns from "Old Ironsides"
.................. Rear Admiral H. J. Ziegemeier, U. S. N.
 Commandant, 13th Naval District, and Staff

Song — "America" Assembly

Benediction Com. R. L. Lewis, Chaplain Corps, U. S. N.
 Chaplain, U. S. S. Idaho

THIRD ANNUAL MEMORIAL DAY PROGRAM. This was the official Memorial Day program for Thursday, May 30, 1929, at the Veterans Memorial Cemetery in Washelli Cemetery. During the ceremony, flowers were dropped over the symbolic grave by a squadron of airplanes from the U.S. naval air station at Sand Point. (Courtesy Evergreen-Washelli Cemetery.)

MEMORIAL DAY CELEBRATION. This 1929 photograph depicts a Memorial Day service with wicker chairs and a piano onstage. The Washelli Community Mausoleum in the background is surrounded by well-kept lawns, flowers, and shrubbery. The whole atmosphere is one of peace and comfort for the living, and tender respect for the dead. (Courtesy Evergreen-Washelli Cemetery.)

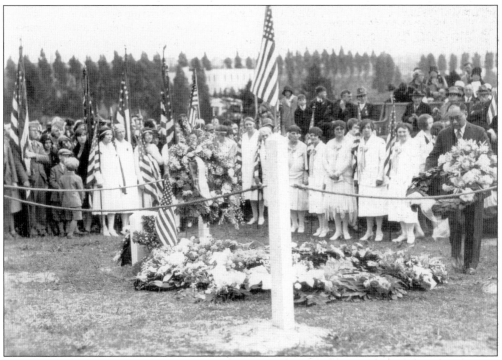

CHINESE COUNCIL PLACING FLOWERS. Around the late 1920s or early 1930s, the Chinese Council was placing flowers on the symbolic grave on Memorial Day in the Veterans Memorial Cemetery. The back of the photograph says, "Evergreen-Washelli Memorial Park Company." (Courtesy Evergreen-Washelli Cemetery.)

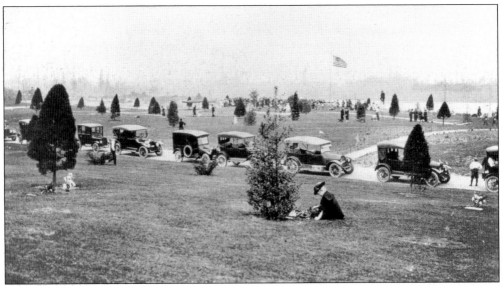

MOURNER AT GRAVE. On Memorial Day, May 30, 1928, an unidentified woman is pictured sitting graveside. (Courtesy Evergreen-Washelli Cemetery.)

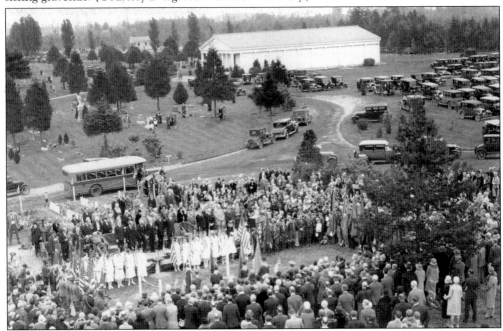

MEMORIAL DAY CELEBRATION, MAY 30, 1931. Thousands pay tribute to the nation's heroes at Washelli in Veterans Memorial Cemetery. Preceding the program, a huge parade headed by flags of the United States and its allies, along with all of the colors of our veterans, marched and stopped at the symbolic grave before finishing at the speaker's platform. Over 15,000 people attended, and the speeches were broadcast on KOMO. Rice W. Means, former national commander of both the Veterans of Foreign Wars and United Spanish War Veterans, was the principal speaker at this engagement paying tribute to our nation's heroes. At high noon, local guardsmen shot off a 21-gun salute using a battery of war-scarred French "75s." Music was provided by the 146th Field Artillery Band and the Seattle Pipe Band. (Courtesy Evergreen-Washelli Cemetery.)

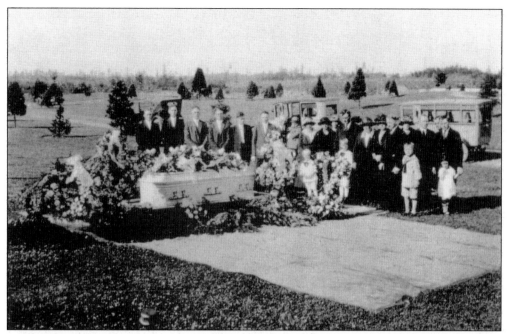

EARLY FUNERAL. This unidentified family poses for the camera at an early funeral (around the 1920s or 1930s) in Evergreen Memorial Park. Note the heavily adorned casket and the ornate flowers surrounding the casket. (Courtesy Evergreen-Washelli Cemetery.)

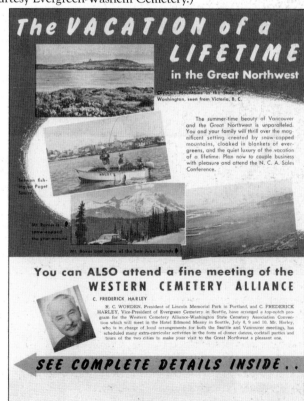

THE VACATION OF A LIFETIME. "The summer-time beauty of Vancouver and the Great Northwest is unparalleled. You and your family will thrill over the magnificent setting created by snow-capped mountains, cloaked in blankets of evergreens, and the quiet luxury of the vacation of a lifetime." (Courtesy Evergreen-Washelli Cemetery.)

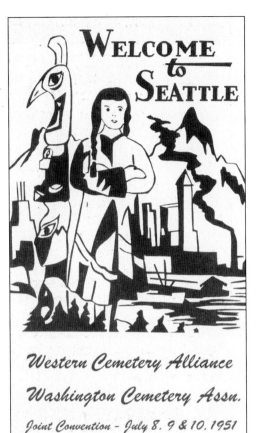

WELCOME to SEATTLE

Western Cemetery Alliance
Washington Cemetery Assn.
Joint Convention - July 8, 9 & 10, 1951

WELCOME TO SEATTLE. Here is a Western Cemetery Alliance advertisement for a joint convention dated July 8, 9, and 10, 1951. C. Fredrick Harley, president of the Washington State Cemetery Association, welcomed them: "Kla-how-ya! Cloish Tillicums, Klootchmen, chee Chakos. It is a great pleasure for us to welcome you to this convention and potlatch. We sincerely hope you all have a most pleasant and worthwhile experience and that you klatawa kopa mica tillicums happily from this skookum illahee!" Most events were held at the Meany Hotel. On Tuesday after dinner, the attendees were invited by all of the Harleys to join them at Kathleen and Fred Harley's home, Harleywood, in Laurelhurst for an "Oriental Evening." (Courtesy Evergreen-Washelli Cemetery.)

Kla - how - ya!

CLOISH TILLICUMS, KLOOTCHMEN, CHEE CHACKOS —

It is a great pleasure for us to welcome you to this convention and potlatch. We sincerely hope you all have a most pleasant and worthwhile experience and that you klatawa kopa mica tillicums happily from this skookum illahee!

Most Cordially -

C. Frederick Harley
C. Frederick Harley, President
Washington State Cemetery Association.

SUNDAY, JULY 8th: ALL EVENTS EDMOND MEANY HOTEL UNLESS NOTED
(DAYLIGHT TIME) (REGISTRATION INCLUDES ITEMS NOT PRICED)

1 to 7 p.m. Registration, Hospitality and Information Desk in Lobby.

3 to 4 p.m. Round Table Discussions:

> Cemetery Planning and Development Gold Room - Mezzanine.
> Moderator - Elmer E. Sears, Manager Forest Lawn Cemetery, Seattle.
>
> Mausoleum Planning and Development Green Room - Mezzanine.
> Moderator - Fred H. Burnaby, President Acacia Memorial Park, Seattle.

4 to 5 p.m. Round Table Discussions:

> Cemetery Maintenance and Service Gold Room - Mezzanine.
> Moderator-Arthur J. Clausen, Mgr., Holy Cross Cemetery, Spokane.
>
> Mausoleum and Crematory Maintenance & Service Green Room-Mezzanine.
> Moderator - Lou R. King, Manager Washelli Crematory & Columbarium.

7 to 9:30 "GATEWAY TO THE ORIENT" (An Evening of Divertisment)
After your dinner, all the Harleys cordially invite you to join them at Kathleen and Fred Harley's home "Harleywood in Laurelhurst" for an Oriental Evening. There will be bits of entertainment, gay music, weird sights, pleasant refreshment and friendship 'cross the sea.

Wear clothing suitable for the weather as much of the time you will be out of doors. (If it should rain we will stay at the Meany Hotel.)

Take the chartered coach with the sign "Gateway To The Orient" if you are at the hotels. This will save on parking and you won't be lost in our winding streets. The coach will leave as follows:

Wilsonian		Edmond Meany		Harley's	
Wilsonian	6:45	Edmond Meany	6:50	Harley's	7:00
"	7:10	"	7:15	"	7:25
"	7:35	"	7:40	"	7:50
"	8:00	"	8:05	"	8:15
"	8:25	"	8:30	"	8:40
"	8:50	"	8:55	"	9:05
"	9:15	"	9:20	"	9:30
				Last Coach Leaves Harley's	9:50

(The address is 4505 East 33rd for Seattleites who drive.)

WELCOME TO SEATTLE (CONTINUED). The invitation said, "Monday evening July 9, all people with cars are asked to load up at Meany or Wilsonson to take conventioneers to the pier for the cruise. The Steamer, *Sightseer*, leaves the pier at Show Boat Theatre on campus for a cruise thru Lake Union, the Canal, the Locks, across Puget Sound to Agate Pass, past the burial place of Chief Sealth, under the new bridge joining Bainbridge Island to the Olympic Peninsula and thru the Narrows to Laura and Clint Harley's summer home. A fine salmon dinner, included in your registration or Cruise Ticket, will be served on board the 'Sightseer.' " (Courtesy Evergreen-Washelli Cemetery.)

MONDAY - JULY 9th: (PROGRAM BY WASHINGTON CEMETERY ASSOCIATION)

8 to 4 p.m. Registration, Hospitality and Information Desk in Lobby.

8 to 4 p.m. Suppliers Display on Mezzanine east of elevator. SEE IT.

8 to 9:45. Breakfast Discussions: College Room (Buy Ticket Sunday - $1.50).
Cemetery Headaches Moderator - Ivan A. Swarthout, Manager of Sumner Cemetery, Sumner, Washington
Mausoleum and Crematory Headaches Moderator - Zene R. Maulsby, Manager of View Crest Abbey, Everett, Washington

10 to 3:30 Western Cemetery Alliance Board Meeting & Lunch, Gold Room.

10:00 a.m. Convention Session Convenes in Black and White Room, Chairman, Herbert C. Ford, Mgr. Tacoma Mausoleum Association and Convention Program Chairman, Washington Cemetery Association.

10:05 Greeting from Seattle and Washington Cemetery Association.
C. Frederick Harley, President.

10:10 Legislative Problems (and five minutes of questions).
Senator Clinton S. Harley, President Evergreen Cemetery Co. of Seattle.

10:25 Washington's Abandonment Law (and five minutes of questions).
A. B. Swensson, Manager Lake View Cemetery, Seattle.

10:40 Interment Technique (and five minutes of questions).
J. E. Vandiveer, Superintendent New Tacoma Cemetery, Tacoma.

10:55 Endowment or Perpetual Care? (and five minutes of questions).
Raymond Louis Brennan, Editor Cemetery Legal Compass, Los Angeles.

*11:10 Ten Minute Stretch Announcements Singing Herbert C. Ford and Byron L. Swanson, Song Leaders. LET'S REALLY PUT IT OUT !!!

11:20 Memorial Dealers and Manufacturers Headaches (ask questions).
Stuart N. Greenberg, M. Greenberg's Sons, San Francisco
and
Byron L. Swanson, Washington Monumental Co., Spokane.

11:50 You Ask The Questions On Your Problem And Some One Will Answer.
Moderator - C. Frederick Harley, Vice President Evergreen & Washelli.

*12:10 Adjournment of Session * Please stay till breaks if possible.

12:30, 12:35, 12:40, 12:45 Coaches leave Meany Hotel for University Campus.
12:30, 12:40 Coaches leave Wilsonian for University Campus.
Luncheon will be at Student Union Building (Buy your own Luncheon).

1:45 Coach Tour of Seattle (An Unique Seaport) leaving Student Union.
Cross the largest floating bridge in the world, etc., etc., etc. Also see many Seattle Cemeteries, Mausoleums, Crematories and see the grave digger and other equipment actually working!!!!!

4:45 Coaches return to Hotels

Totem - Tum Tum

TUESDAY EVENING - JULY 10th.

7:00 Cocktails - Guests of Seattle Cemeteries - Black and White Room.

8:00 Convention Banquet - Ball Room (Men business suits please).
Toastmaster: Clinton S. Harley (Chief Smokum Pipe).

Invocation by the Reverend John G. Mattie.

The National Anthem. Leader Herbert C. Ford.

9:15 Introduction Of Distinguished Guests

Greeting From The City of Sealth (New York - Alki).
Payne Karr, President-Elect of the Seattle Chamber of Commerce.

Response From New York City
Dr. A. M. Stannard, President National Cemetery Association.

The Wide Open Spaces
J. F. Eubank, President Western Cemetery Alliance.

Songs: Byron L. Swanson and/or Herbert C. Ford.

Mamook Ta-man-a-wis :
President-elect Washington State Cemetery Association or
Washington Interment Association (?)

9:40 Adjournment to Lobby.

10:00 Dancing the Light Fantastic TOTEM TUM TUM - TOTEM TUM TUM :
In the Ballroom - Meany Hotel.

12:00 THE TIDE EBBS
The old chief wanted to die under the open sky -- young men carried him carefully out of the ancient potlatch house and laid him on the sandy beach. Placid waters of Agate Pass spread like azure reflected from the noonday heat. The tide crept in quietly, and at its flood seemed briefly to stand still - as if waiting. By the time that Puget Sound tide would have ebbed completely the soul of the noble Chief Sealth would also have slipped peacefully away on the tide of eternity.
High overhead gulls wheeled in slow spirals -

Tillikums - Klatawa - Skookum Potlatch - Skookum Illahee !
May the great spirit go with each of us as we good friends leave this good potlatch - this good land ! Come back some other time.

Those who go north to our fine neighbor Canada tomorrow should go to bed early so they may rise and catch the Coach which leaves at

7:45 a.m. sharp for the C.P.R. Steamer which leaves pier promptly at

9:00 a.m. daylight time whether you are on board or not. If you do not have your steamer tickets or Coach Tickets get them from Lou King tonight without fail

79

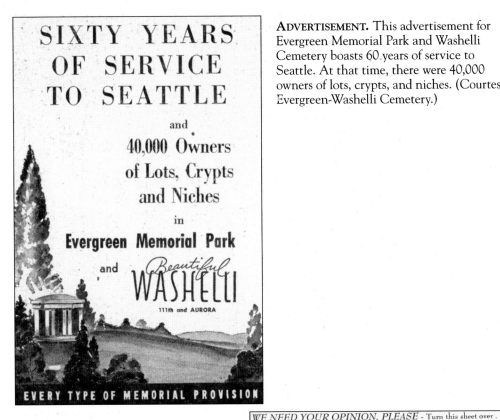

SIXTY YEARS OF SERVICE TO SEATTLE

and
40,000 Owners
of Lots, Crypts
and Niches

in

Evergreen Memorial Park

and *Beautiful* WASHELLI

111th and AURORA

EVERY TYPE OF MEMORIAL PROVISION

ADVERTISEMENT. This advertisement for Evergreen Memorial Park and Washelli Cemetery boasts 60 years of service to Seattle. At that time, there were 40,000 owners of lots, crypts, and niches. (Courtesy Evergreen-Washelli Cemetery.)

WE NEED YOUR OPINION, PLEASE - Turn this sheet over . . .
Give us your views . . . Take a complimentary flower . . . and our thanks!!

By and For Women

Do you know that Evergreen-Washelli
will honor a request to be 'served by women'?

You may be more comfortable if your deceased loved one's
preparation for cremation or burial was directed by women –
or if you could specify such service for yourself.

❖ *For emergency funeral and cemetery services*

Sarah Hansen
Licensed Funeral Director

Bev Kané
Licensed Funeral Director

Mary Jane Robbins
Service Counselor

Genevieve Olivarez-Conklin
Service Counselor

❖ *For services in the future*

Marganna King
Memorial Counselor

Mary Johnson
Memorial Counselor

Sandi Colleton
Memorial Counselor

Evergreen-Washelli

MEMORIAL PARK and FUNERAL HOME
11111 Aurora Avenue North, Seattle, WA 98133
206 / 362 - 5200
24-hour human response

We share your concerns about cost

EVERGREEN-WASHELLI ADVERTISEMENT. This Evergreen-Washelli advertisement, "By and For Women," pointed out that if one wished to be "served by women" in preparing a body for burial, that could be arranged at the funeral home. Note the promise to provide a "24-hour human response" at the bottom of the scan. (Courtesy Evergreen-Washelli Cemetery.)

EVERGREEN-WASHELLI UNEARTHS RELICS. Dave Daly and Marylou Evans inspect an old horseshoe found at Evergreen Washelli Cemetery in the top photograph. In the photograph below are two unidentified men with two draft horses. The horseshoe that was found was an old cast-iron type that was worn by a heavy draft horse like those pictured below. In 1884, when the cemetery was founded, they built a barn for the horses. As part of the sexton's job he fed the horses. The barn remained in use as an equipment shed until it was demolished in the late 1950s. Half of all of the land at Evergreen-Washelli was cleared by man and horse teams. Evergreen-Washelli has old 16mm film showing horse teams clearing the cemetery and at one time had plans for restoring them. (Courtesy Evergreen-Washelli Cemetery.)

GREENHOUSE AT EVERGREEN MEMORIAL PARK. This old photograph shows the original greenhouse behind Evergreen Memorial Park. Pictured from left to right are Larson, Bob Fish, unidentified, and Tom Lee. The greenhouse has been demolished. (Courtesy Evergreen-Washelli Cemetery.)

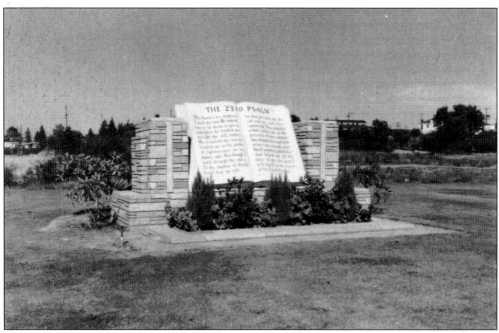

THE 23RD PSALM. "A Psalm of David: The Lord is my shepherd; I shall not want. He maketh me to lie down in green pastures: he leadeth me beside the still waters. He restoreth my soul: he leadeth me in the paths of righteousness for his name's sake. Yea, though I walk through the valley of the shadow of death, I will fear no evil: for thou art with me." (Courtesy Evergreen-Washelli Cemetery.)

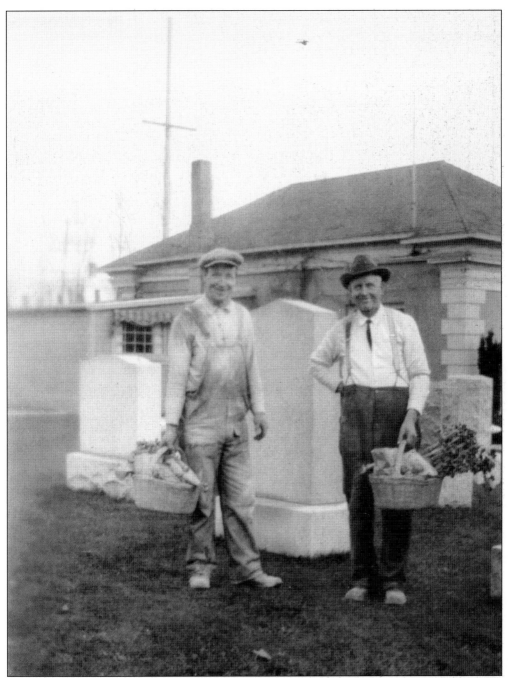

EVERGREEN-WASHELLI THANKSGIVING BASKETS. This article ran in the *Tribune Review* on December 6, 1929: "D. D. Graves, one of the fifty employees of Evergreen Cemetery Company, smiles with satisfaction as he displays the contents of the Thanksgiving basket presented to him by C. S. Harley. Thanksgiving is a big day for employees of Evergreen Cemetery Company, owners and operators of Evergreen Memorial Park and Washelli Cemetery. For the past four years Mr. Harley, president, has given each employee a well-filled basket, including everything 'from soup to nuts' as an expression of his appreciation of their loyalty." (Courtesy Evergreen-Washelli Cemetery.)

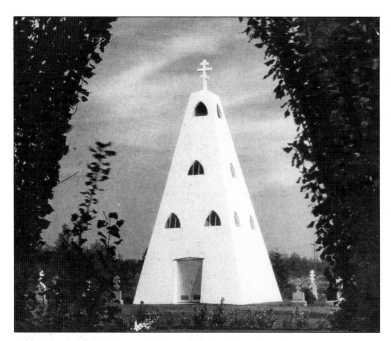

RUSSIAN CEMETERY CHAPEL. This monument in honor of Russian War veterans was photographed on August 30, 1936. The historic Russian Chapel is shown framed by the famous poplars at Washelli Cemetery. In 2006, the St. Nicholas Russian Orthodox Cathedral collected donations for a new coat of paint. (Courtesy Evergreen-Washelli Cemetery.)

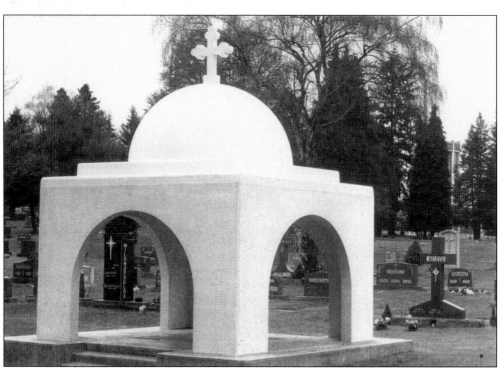

GREEK ORTHODOX CHAPEL. This chapel was built over six graves and in memory of the Reverend Dr. A. Homer Demopulos Protopresbyter, beloved pastor and shepherd of St. Demetrios Church (1968–1993). "Let your light so shine before men, that they may see your good works and glorify your father which is in heaven." —Matthew 5:16. (Courtesy Evergreen-Washelli Cemetery.)

LA GAVIOTA. This sculpture memorializing Fredrick Potter Harley, the son of Clinton and Laura Harley, is named *La Gaviota*: a bronze gull that sits within a reflective pond. The sculptor of *La Gaviota* was Dudley Pratt. (Courtesy Evergreen-Washelli Cemetery.)

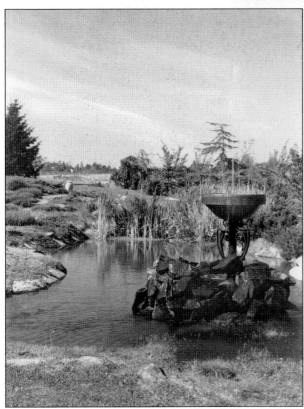

MEMORY GLEN. This photograph of Memory Glen was taken by Loren Smith of Seattle. Centered in the Memory Glen section of the cemetery, ground burial for urns was instituted in 1933. Cremation was rare at the beginning of the century but has become more prevalent in recent years. (Courtesy Evergreen-Washelli Cemetery.)

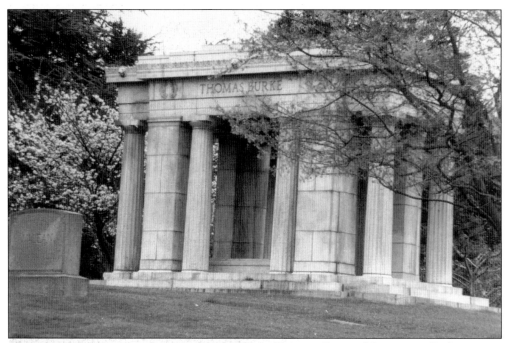

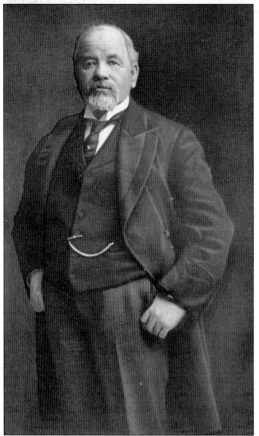

THOMAS BURKE MEMORIAL. Burke (1849–1925) was born in Chateauguay, New York, and was of Irish descent. He was a probate judge in Washington from 1876 to 1880 and was a justice of Washington Territorial Supreme Court in 1888. He married Caroline McGilvra in 1879. Burke collapsed while speaking at the Carnegie Endowment in New York. Dr. Butler, president of Columbia University, caught him as he fell. Butler stated that Burke died "in the midst of an eloquent and unfinished sentence which expressed the high ideals of international conduct." (Courtesy Evergreen-Washelli Cemetery.)

THOMAS BURKE. Burke is known as the "Man Who Built Seattle." He came to the city in 1875. Besides his interests in the law, he promoted the railroad, pushed for higher education, and was a great civic leader. Burke was influential in promoting racial tolerance during the anti-Chinese riots of February 1886. The Burke-Gilman Trail and the Burke Museum are named for him. (Courtesy Clarence Bagley.)

HENRY LANDES MEMORIAL.
Landes, dean of the College of
Science (1895–1936) became the
head of the geology department
at the University of Washington
(UW). He taught physiology, a
course in terrestrial physics, and
geography at UW, and he served as
state geologist from 1901 to 1921.
In 1905, Landes wrote field notes of
Mount Rainier. He married Bertha
Knight Landes (1868–1943), who
was the first female executive of a
major city. (Courtesy Evergreen-
Washelli Cemetery.)

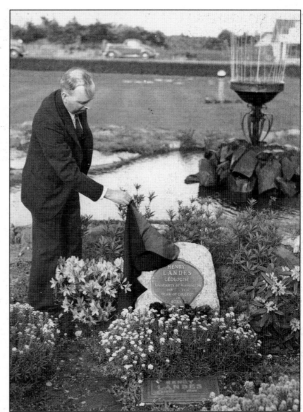

BERTHA KNIGHT LANDES. Landes was the
first female mayor of Seattle, from 1926
to 1928. When she ran for city council,
her husband said, "It's simply the natural
enlargement of her sphere. Keeping house and
raising a family are woman's logical tasks, and
in principle, there's no difference between
running one home and a hundred thousand."
Landes is purported to haunt the Harvard Exit
Theatre on Capital Hill. (Courtesy Seattle
Municipal Archives, No. 12285.)

C. D. STIMSON MONUMENT.
Stimson (1827–1928) built the
Stimson Lumber Company on
Salmon Bay in Ballard. His wife
was Harriett Overton Stimson
(1862–1936), who was founder of
the Seattle Symphony, Children's
Orthopedic Hospital, and the
Visiting Nurse Service and who
donated a large sum of money to
the Cornish school. (Courtesy
Evergreen-Washelli Cemetery.)

STIMSON MILL COMPANY. This photograph, dated October 12, 1915, shows the main entrance to the Stimson Mill Company's plant. Stimson and his wife, Harriett, and his son Thomas moved to Seattle in 1889. He soon established Stimson Mill Company, with his brothers and father as directors. On June 6, 1889, the great Seattle fire created an immediate demand for the mill's products. (Courtesy Seattle Municipal Archives, No. 51925.)

STIMSON MANSION. This 1901 photograph shows the Stimson Mansion, built by C. D. and Harriett Stimson. The mansion is now called the Stimson-Green Mansion, is located at 1204 Minor Avenue on First Hill, has been fully restored, and is available for weddings and other events. The mansion is an example of "eclectic architecture." (Courtesy the Washington Trust for Historic Preservation.)

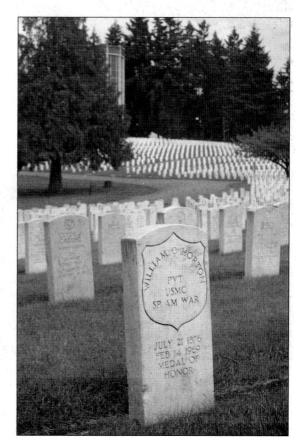

WILLIAM C. HORTON MARKER. Horton (1876–1969) received the Congressional Medal of Honor during the Boxer Rebellion as a private in the U.S. Marine Corps. His citation reads, "In action against the enemy at Peking, China, 21 July to 17 August 1900. Although under heavy fire from the enemy, Horton assisted in the erection of barricades."

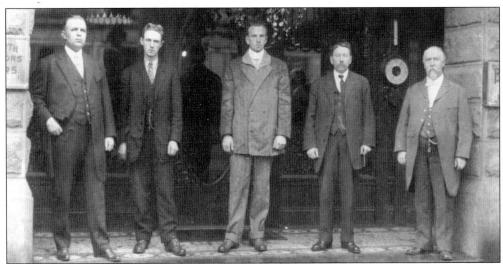

BUTTERWORTH FAMILY, C. 1919. Shown here from left to right are G. M. Butterworth, Ben Butterworth, Fred Ray Butterworth (December 25, 1877–August 3, 1929), Charley Butterworth, and founder Edgar Ray Butterworth. E. R.'s fifth son, Harry Edgar Butterworth (September 1, 1889–May 19, 1913), had died by the time this picture was taken. (Courtesy Bert Butterworth Jr.)

IDENTITY KIT FOR UNKNOWN SOLDIERS. This kit was developed for field use in identifying unknown dead for World War II. Note the shovel for fingerprinting, which could be rotated on the finger instead of attempting to rotate the finger. These shovels assured a good print. (Courtesy Bert Butterworth Jr.)

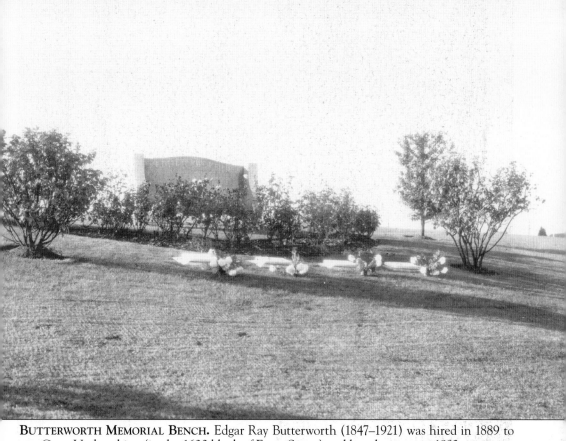

BUTTERWORTH MEMORIAL BENCH. Edgar Ray Butterworth (1847–1921) was hired in 1889 to run Cross Undertaking (in the 1600 block of Front Street) and bought it out in 1892, renaming it E. R. Butterworth and Sons. Fred was born December 25, 1877, in Mule Creek, Kansas. He moved with his father as an infant to Centerville (now Centralia) in the late 1870s and moved to Seattle when his father was hired to run Cross Undertaking. Edgar Ray was buried at Mount Pleasant originally, then disinterred, and reburied at Evergreen on July 6, 1922. (Courtesy Evergreen-Washelli Cemetery.)

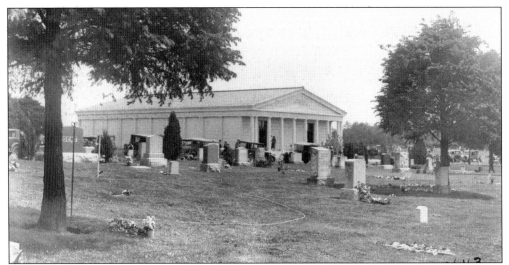

WASHELLI MAUSOLEUM. Described in this promotional pamphlet, Washelli Mausoleum built in 1921, was a "palace of granite, marble and bronze making it as secure and time resisting as the pyramids of Egypt. If you would give your loved ones the same precious privilege you must act at once before it is too late." (Courtesy Evergreen-Washelli Cemetery.)

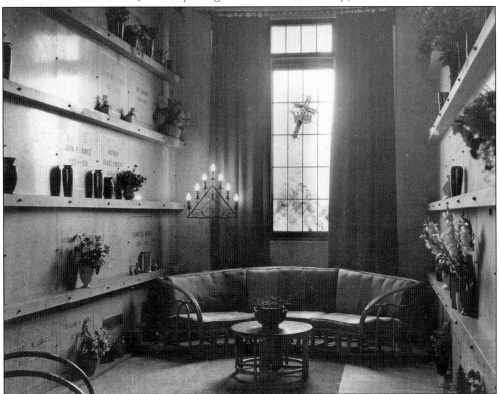

INTERIOR VIEW OF WASHELLI MAUSOLEUM. This c. 1930 photograph shows the elaborate interior of the Washelli Mausoleum. An advertisement said, "Over 400 leading families of Seattle and vicinity have chosen this everlasting building as their final resting place." (Courtesy Evergreen-Washelli Cemetery.)

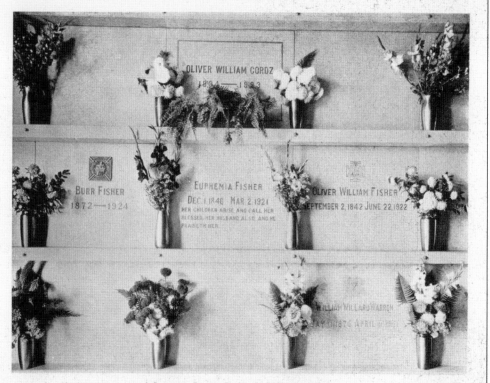

A BEAUTIFUL RESTING PLACE AND PERMANENT MEMORIAL

A sacred spot of beauty, where you can go and have the feeling that you are near to your loved ones, only separated by the partition of marble, and that you know that within that hallowed tomb of snow-white, the form and face you loved so well in life is there exactly as you placed it in this holy spot.

INTERIOR VIEWS OF WASHELLI MAUSOLEUM. These early photographs show a beautiful resting place, a permanent memorial (above), and the family crypt section (below). The promotional pamphlet states, "The interior is finished throughout with beautiful marble of contrasting shades, lending the soft colors necessary to relieve the snow white of the building. That is one of the reasons it attracts such admiration from all beholders. It provides a place where family and friends may lie side by side, high and above ground where neither water, damp nor mold can enter." (Courtesy Evergreen-Washelli Cemetery.)

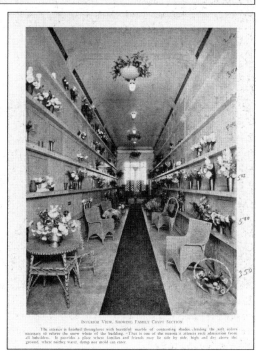

INTERIOR VIEW, SHOWING FAMILY CRYPT SECTION

The interior is finished throughout with beautiful marble of contrasting shades, lending the soft colors necessary to relieve the snow white of the building. That is one of the reasons it attracts such admiration from all beholders. It provides a place where families and friends may lie side by side, high and dry above the ground, where neither water, damp nor mold can enter.

ROSE HILL MAUSOLEUM. This is an exterior view of Rose Hill Mausoleum, which is also located at beautiful Washelli Cemetery. As the Washelli Mausoleum proved to be so popular and the space was filled, Rose Hill Mausoleum was opened with a limited number of crypts. (Courtesy Evergreen-Washelli Cemetery.)

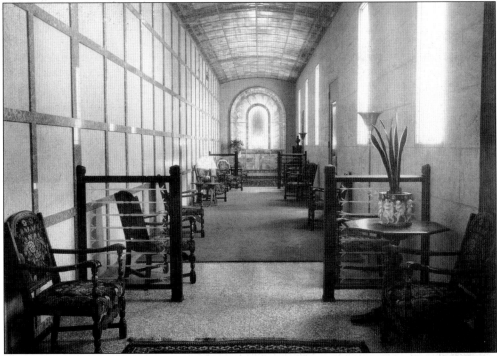

ROSE HILL MAUSOLEUM. This c. 1929 photograph shows the interior of the Rose Hill Mausoleum. An advertisement claimed, "It will be to the advantage of everyone interested in Mausoleum entombment to investigate before all of these moderately priced crypts are disposed of." (Courtesy Evergreen-Washelli Cemetery.)

BRONZE ROOM. This photograph was taken by Tackett Studio of Seattle and shows the Bronze Room. An advertisement said, "The niches for urns are sold outright on easy terms." It goes on to say, "A certificate of ownership is issued on every sale, and the first cost is the only cost." (Courtesy Evergreen-Washelli Cemetery.)

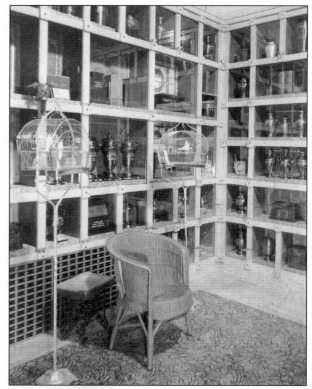

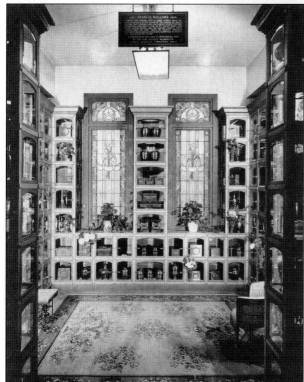

FRANCIS WILLARD COVE. This photograph shows the Francis Willard Cove in the columbarium. One advertisement described the "Columbarium rooms, in which rest the incinerated remains of the dead are beautiful, comforting and restful. The daylight through the windows is softened by tinted art glass." (Courtesy Evergreen-Washelli Cemetery.)

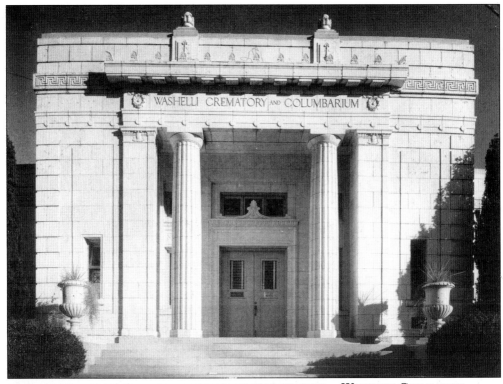

WASHELLI CREMATORY AND COLUMBARIUM. The photograph above shows the wonderful architecture of the Washelli crematory and columbarium as they looked in 1921. An advertisement said, "A solid concrete construction, reinforced with steel, renders this building thoroughly fireproof. The exterior is a beautiful cream white terra-cotta and the interior is pleasing in every detail." In the photograph below is the same building after 1960, the remodel, showing the pneumatic hoist in front of the steps. The pneumatic hoist was used to lift bodies from the street level, where they were delivered by hearse up to the top step for easy entry into the crematory building. (Courtesy Evergreen-Washelli Cemetery.)

Three

MOUNT PLEASANT CEMETERY

This historic cemetery is on the north side of Queen Anne Hill in Seattle and was started in 1879. The original homestead land grant was given to Nils Peterson in 1878. A year later, the International Organization of Odd Fellows purchased 10 acres near this homestead for the purpose of a cemetery but accidentally located the burial ground on Peterson's land. Peterson thus sold that part of his homestead to International Organization of Odd Fellows.

In 1882, Peterson sold another 10 acres to the Free Methodist Church. It is believed this second cemetery formed Mount Pleasant Cemetery. Originally on Queen Anne Hill, two separate burial grounds existed.

Seattle undertakers Cross and Company also bought land from Peterson in 1882. In 1890, Congregation Chaveth Sholem established the first Jewish cemetery.

Mount Pleasant Cemetery Company was started by James W. Clise (1885–1938), a real estate investor and banker when he purchased the land from Cross. In 1929, Mount Pleasant sold a parcel of its cemetery to Temple de Hirsch for the Hills of Eternity Jewish cemetery. Another parcel was sold to the Chinese Chong Washington Benevolent Society. The neglected Mount Pleasant Cemetery was sold by Clise to Neil Edwards (1908–1986).

Mount Pleasant Cemetery and the Odd Fellows cemetery are under the same management, and the boundaries between them have merged over time. The Jewish cemetery, Hills of Eternity, and the A. A. Wright Columbarium are still separate. Muslim grave sites oriented toward Mecca were started in 1979.

Buried at Mount Pleasant Cemetery are several Wobblies killed during the Everett Massacre (Bloody Sunday) when there was an armed confrontation between members of the Industrial Workers of the World (IWW) and the local authorities. On Sunday, November 5, 1916, hundreds of members of the IWW boarded the steamers *Calista* and *Verona* from Seattle and headed to Everett to attend a rally. They were met at the docks by Sheriff Donald McRae and over 200 citizen deputies. McRae told the Wobblies that they could not rally in the spot. Arguing ensued, then shots rang out on both sides. Two deputies died along with five Wobblies, and several men were wounded. Along with other prominent citizens from Seattle, three of the Wobblies are buried here at Mount Pleasant Cemetery.

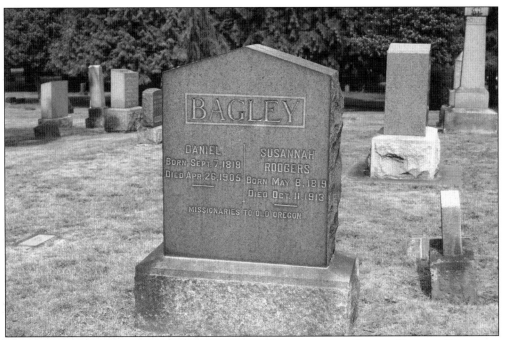

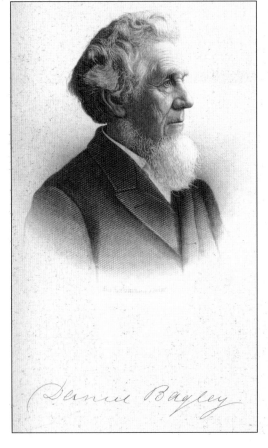

Daniel Bagley

TOMBSTONE OF DANIEL BAGLEY. Rev. Daniel Bagley (1818–1905) was married to Susannah Rogers Whipple. In 1842, Bagley was admitted into the ministry of the Methodist Protestant church, and for 10 years he was engaged in active work. In 1852, he was chosen by the board of missions of his church for a mission to Oregon Territory, which then included Washington and Idaho and parts of Montana and Wyoming.

DANIEL BAGLEY. In 1852, Bagley and his wife arrived at The Dalles in Oregon, where he began active missionary work that lasted for eight years. In 1860, they moved to Seattle, and at that time he was the only clergyman stationed in Seattle. Besides his ministerial duties, he became a prominent worker for the advancement of Seattle. He was in charge of the Brown Church for many years. (Courtesy Clarence Bagley.)

TOMBSTONE OF CLARENCE BAGLEY.
Bagley (1843–1932) was born in
Troy Grove, near Dixon, Illinois.
In 1852, he became a student at the
Willamette Institute (Willamette
University) in Salem. He helped clear
the land for the Seattle University
(UW) when he moved with his
family to Seattle. In 1865, he married
Alice Mercer.

CLARENCE BOOTH BAGLEY.
Bagley became a writer, a printer,
a publisher, Seattle's first historian,
and a founder of the Washington
State Historical Society. He was a
collector of data concerning history,
and he wrote more history articles for
publication than any other resident of
Washington. He wrote three volumes
of *History of Seattle* (1916) and three
volumes of *History of King County*
(1929). (Courtesy Clarence Bagley.)

BERTHA PITS CAMPBELL MARKER. Campbell (1889–1990) was a founder of the Christian Friends for Racial Equality, was one of 22 women who founded the black sorority Delta Sigma Theta, and was a civil rights leader. Seattle proclaimed June 13, 1987, as Bertha Pitts Campbell Day.

MONUMENT FOR VALENCIA MARITIME DISASTER. A total of 26 people are buried here from a maritime disaster off Vancouver Island in January 1906. This monument honors those persons who died on the SS *Valencia*, which was en route from San Francisco to Seattle, passed the entrance to the Strait of Juan de Fuca in foul weather, and ran aground. In the worst maritime disaster of Northwest history, 136 people perished. There were 37 survivors.

MAYOR ORANGE JACOBS. Jacobs (1827–1914), mayor of Seattle from 1879 to 1880, was a member of Washington territorial council from 1885 to 1887 and was a superior court judge from 1896 to 1900. On September 27, 1881, he delivered a eulogy after Pres. James A. Garfield was assassinated. The memorial was attended by approximately 3,500 people, a huge crowd for Seattle at that time. (Courtesy Seattle Municipal Archives, No. 12261.)

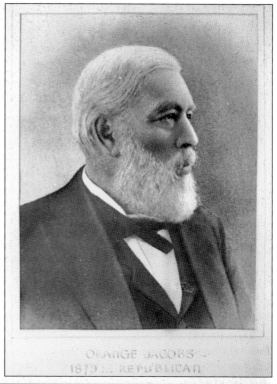

WELLINGTON TRAIN DISASTER: LUIGI CIMMARUSTI. In 1910, near the town of Wellington (renamed Tye), an avalanche took the lives of 96 people. One of the survivors stated, "There was an electric storm raging at the time of the avalanche. Lightning flashes were vivid and a tearing wind was howling down the canyon. Suddenly there was a dull roar, and the sleeping men and women felt the passenger coaches lifted and borne along. When the coaches reached the steep declivity they were rolled nearly 1,000 feet and buried under 40 feet of snow."

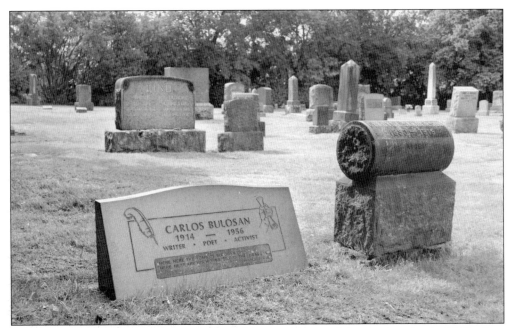

CARLOS BULOSAN. Filipino author Carlos Bulosan was born in Mangusmana in the Philippines and was the son of a farmer. American colonization brought hardship to many families; Bulosan left his country behind for dreams in America and arrived in Seattle on July 22, 1930, at the age of 17. His dreams were shattered when he found racial brutality and economic injustice in the land of the free. From unhealthy work conditions, he contracted tuberculosis. He became a prolific writer on the subject of his hardships and social injustice in America. He died from bronchopneumonia.

ANNA HERR CLISE. Anna Herr Clise (1866–1936) was a cofounder of Children's Orthopedic Hospital, creating a safe haven for malnourished and crippled children. Clise and 23 affluent women contributed $20 each to start the Children's Orthopedic Hospital, which opened on Queen Anne Hill and relocated to Laurelhurst in 1953.

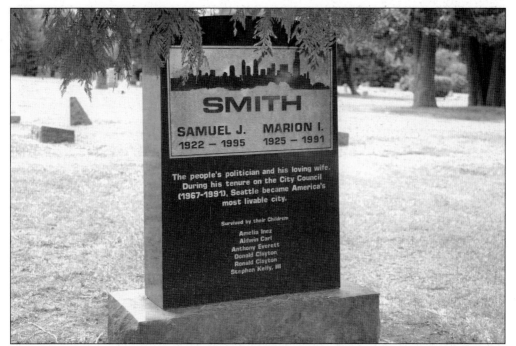

SAMUEL J. SMITH TOMBSTONE. Sam Smith (1922–1995), longtime Seattle city councilman, grew up in Louisiana and at an early age decided to go into politics. Smith was elected to the state house of representatives and served five consecutive terms. In 1967, he achieved his goal of passing a state open-housing law and became the first black person elected to the Seattle City Council. For 24 years, he served on the Seattle City Council.

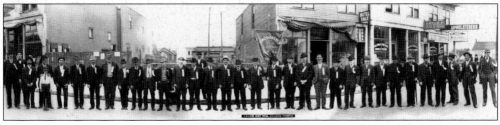

LONGSHOREMAN LABOR DAY. Portrayed here is one of a series of panoramic views taken by photographer J. A. Juleen at Everett's 1912 Labor Day parade. (Courtesy Everett Public Library.)

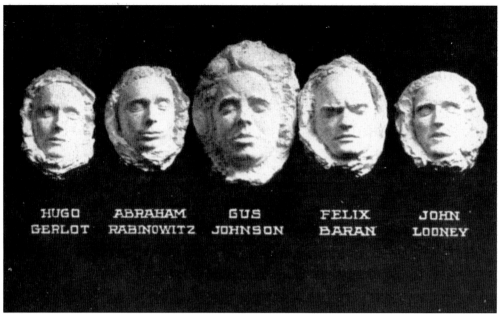

DEATH MASKS. This postcard issued by the Industrial Workers of the World (IWW) shows the death masks of five Wobbly victims. The date was November 1916, and the postcard was issued in memory of their fellow workers killed at the Everett Massacre. (Courtesy University of Washington Library.)

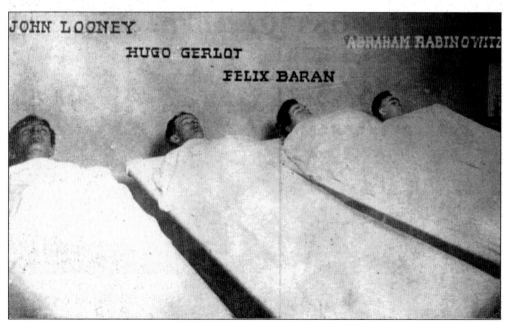

BODIES OF FOUR WOBBLY VICTIMS. This postcard issued by the IWW relates to the Everett Massacre. The four Wobbly victims were John Looney, Hugo Gerlot, Felix Baran, and Abraham Rabinowitz. (Courtesy Everett Public Library.)

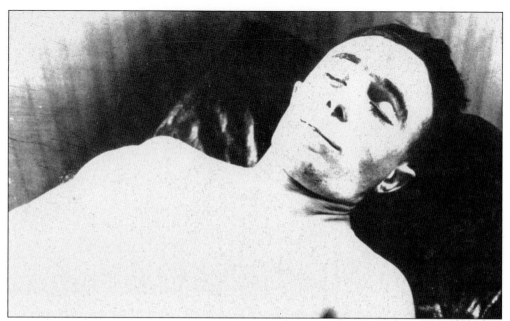

BODY OF ABRAHAM RABINOWITZ. This postcard issued by the IWW shows the body of Rabinowitz, Wobbly victim of the Everett Massacre 1916. (Courtesy Everett Public Library.)

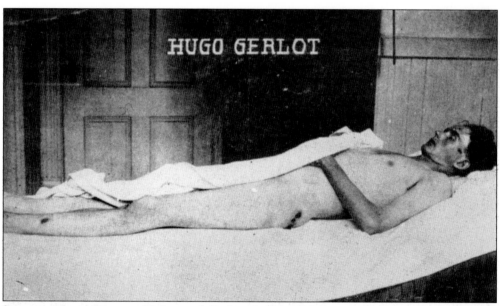

BODY OF HUGO GERLOT. Gerlot was killed in the Everett Massacre on November 5, 1916. On Saturday afternoon, thousands of Seattle citizens viewed the impressive funeral cortege of three martyrs shot dead. Leading the procession was an automobile filled with flowers. One of the flower arrangements had only one word, "Solidarity." The most impressive floral tribute was a massive set of white carnations with the motto in red, "Workers of the World Unite." (Courtesy Everett Public Library.)

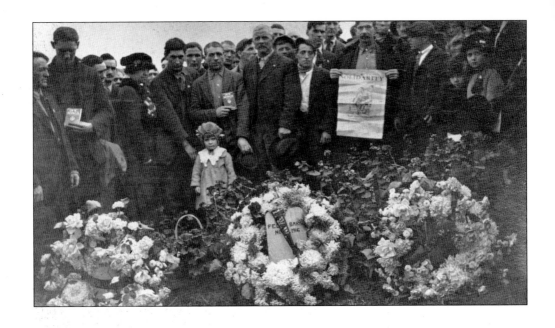

MOUNT PLEASANT FUNERAL, 1916. These photographs show the funeral of Everett Massacre victims. Industrial Workers of the World (Wobbly) supporters gathered at Mount Pleasant Cemetery in November 1916 for the funeral of victims Gerlot, Baran, and Looney. (Courtesy University of Washington Special Collections.)

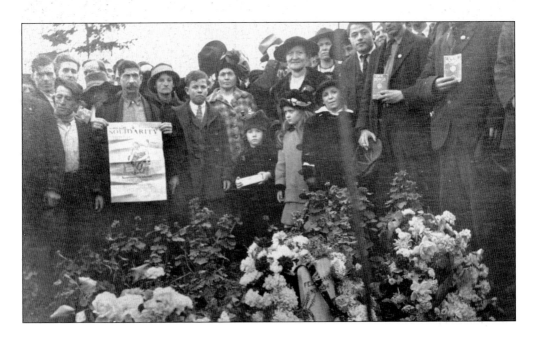

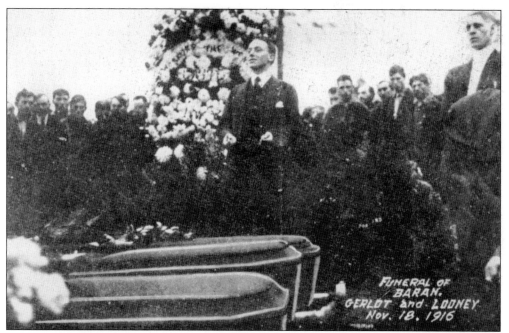

FUNERAL OF FELIX BARAN. Baran was killed at the Everett Massacre in 1916 during a labor dispute. His funeral was held in Seattle in November 1916. This photograph shows Mount Pleasant funeral poet Ashleigh speaking. (Courtesy University of Washington.)

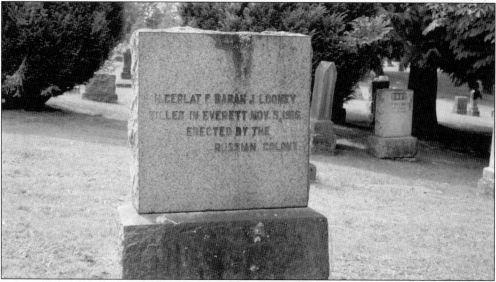

MOUNT PLEASANT WOBBLIES HEADSTONE. On November 5, 1916, over 300 International Workers of the World from Seattle took a ferry to Everett, Washington, for a mass meeting to support an Everett shingle-mill-workers' strike (organized not by the IWW but by an AFL union) and with the intent of pressing the free-speech issue. Two hundred deputies and Sheriff McRae, who had been responsible for the beatings, met the ferry. McRae asked, "Who are the leaders here?" The men on the boat replied, "We are all leaders here!" Shots rang out wildly. We remember Hugh Gerlot, Felix Baran, Abe Rabinowitz, Gus Johnson, and John Looney, the IWWs who died on Bloody Sunday.

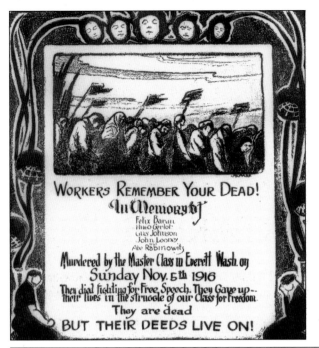

WOBBLY MEMORIAL POSTER. "Workers Remember Your Dead," advises this November 1916 Wobbly memorial poster. Artist M. Pass drew this memorial poster for publication in the *Industrial Worker* newspaper, to remember and honor the five Wobblies killed during the Everett Massacre. (Courtesy Everett Public Library.)

"I speak to you, O workingmen,
O, Toilers of the Sea;
Come organize one union great—
The shipping industry.
When you are thusly organized,
With others like your own;
The One Big Union of the World
Shall rule the earth, ALONE!"

THE PREACHER AND THE SLAVE

By Joe Hill

(Tune: "Sweet Bye and Bye")

Long-haired preachers come out every night,
Try to tell you what's wrong and what's right;
But when asked how 'bout something to eat
They will answer with voices so sweet:

CHORUS

You will eat, bye and bye,
In that glorious land above the sky;
Work and pray, live on hay,
You'll get pie in the sky when you die.

And the starvation army they play,
And they sing and they clap and they pray.
Till they get all your coin on the drum,
Then they'll tell you when you're on the bum:

Holy Rollers and jumpers come out,
And they holler, they jump and they shout.
"Give your money to Jesus," they say,
"He will cure all diseases today."

36

If you fight hard for children and wife—
Try to get something good in this life—
You're a sinner and bad man, they tell,
When you die you will sure go to hell.

Workingmen of all countries, unite,
Side by side we for freedom will fight:
When the world and its wealth we have gained
To the grafters we'll sing this refrain:

Last CHORUS

You will eat, bye and bye,
When you've learned how to cook and to fry
Chop some wood, 'twill do you good,
And you'll eat in the sweet bye and bye.

"THE POPULAR WOBBLY"

(Air: They go wild simply wild over me)

By T-Bone Slim

I'm as mild manner'd man as can be
And I've never done them harm that I can see,
Still on me they put a ban and they threw me in
the can,
They go wild, simply wild over me.

They accuse me of ras—cal—i—ty
But I can't see why they always pick on me,
I'm as gentle as a lamb but they take me for a ram,
They go wild, simply wild over me.

37

SONGWRITER JOE HILL'S ASHES. Joe Hill was executed by the State of Utah by firing squad in 1915 for a murder that he probably did not commit. His ashes are scattered in this cemetery. Small packets of his ashes were sent to Industrial Workers of the World (IWW) (except in Utah) to be scattered. Wobblies on May 1, 1917, sang his songs and spread his ashes at Mount Pleasant cemetery. The lyrics for one of his songs is featured here. (Courtesy Everett Public Library.)

Four

MORTUARIES AND UNDERTAKERS

Seattle undertaking establishments changed names and locations often. In the middle of the 19th century, most undertaking establishments were operated from a woodworking shop as a side business.

A woodworker named Oliver C. Shorey (buried at Lake View Cemetery) who came to Seattle in 1861 to build pillars for the territorial university (UW) was the first known undertaker.

A Seattle directory in 1876 lists two undertakers: E. L. Hall and T. S. Russell, who both also owned cabinet making shops. Hall's undertaking business was sold to Ole Schillestad and T. Coulter. Shorey and Schillestad competed for business. They both applied with the city for burial of the county poor, but Shorey won with a bid of $6.74 per burial.

In 1881, Shorey partnered with L. W. Bonney. In 1885, Schillestad Undertaking went out of business and a new business, Cross and Company (safes and undertakers) was begun. In 1889, Shorey sold his part ownership to G. M. Stewart, so the undertaking establishment changed its name to Bonney and Stewart. In 1903, the same business changed hands again and the name changed once again to Bonney-Watson. Both Bonney and Watson are buried toe-to-toe at Lake View Cemetery.

If you called the number 13 in Seattle in 1892, you would be promptly connected to Bonney and Stewart, as per the Seattle city telephone directory.

Edgar Ray Butterworth started in the funeral directory business in Centralia. He then was hired to run Cross Undertaking (in the 1600 block of Front Street) in 1889 and bought it out in 1892, renaming it E. R. Butterworth and Sons. Butterworth's four sons followed him, and it became a family business. Butterworth built one of the most modern funeral home on the west coast in 1903 and is recognized as owning the first hearse north of the Columbia River.

During the gold rush days, miners returning from Alaska and laden with gold were frequently robbed and dumped in Elliott Bay. A payment of $50 was offered to the funeral director who would scoop them up and bury them. Stories about funeral coaches racing down the streets of Seattle to try to be the first to pick up these bodies are written in a book by Potts.

Early deaths in the 19th century were commonplace, so the families had many children in the hopes that some would survive to carry on the name and help with farming or chores. A family with 12 children would have maybe two or three survive. The dead were almost always buried and not cremated as most Christians thought it "unclean" or endangered the soul.

In 1905, King County Crematory started. Arthur Wright started the Washington State Cremation Society, which later became Arthur-Wrights Funeral Home. In 1913, a second King County Crematory opened. In 1912 Bonney-Watson Funeral home moved to a different location and had a crematory and columbarium installed. E. R. Butterworth and Sons also had a crematory and columbarium. St. Marks Episcopal cathedral also has a columbarium in the basement.

PHEASANT AND WIGGEN AT BUICK DEALERSHIP. This *c.* 1930 photograph taken at the Buick dealership in Ballard shows, from left to right, unidentified, Chester Green (driver), Jack L. Pheasant, and Olaf Wiggen. The Wiggen family left Norwegian shores and in 1915 arrived in Seattle. Arcadia Publishing editor Julie Albright's grandfather J. L. Pheasant started a funeral home, Pheasant-Wiggen Mortuary on Market and Twenty-second in Ballard. He then brought in Norwegian-speaking Wiggen as a business partner. The driver pictured here, Chester Green, opened Green's Funeral Home in Bellevue some years later. The building where the Buick dealership is located is still standing on Market Street. (Courtesy Julie Albright.)

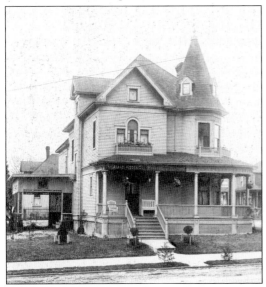

HOME OF JACK PHEASANT. Pictured is editor Julie Albright's grandfather Jack L. Pheasant's home in Ballard. This three-story building contained a funeral home on the bottom floor, living quarters on the second and third floors, and the Ballard telephone exchange in the "turret." The home was sold to pay for the construction of the Ballard Building on the corner of Market and Twenty-second, as well as the building containing Tully's today on the opposite corner. In its place today is Washington Mutual. In business, he partnered with Olaf Wiggen in the mortuary business. There is still a Wiggen and Sons Funeral Home and Bayside Crematory in Seattle on Northwest Fifty-seventh Street. (Courtesy Julie Albright.)

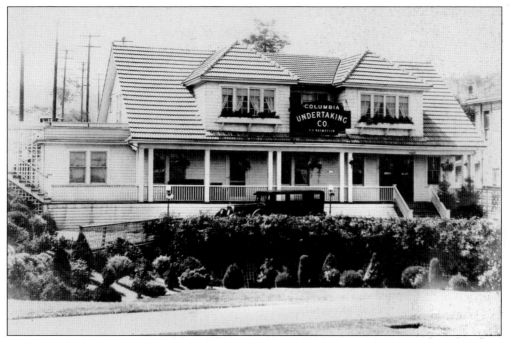

COLUMBIA UNDERTAKING COMPANY. This 1930 photograph was taken on Alaska and Rainier in what was once the Lassen home. It shows the new addition on the left side, a new roof, and a 1927 hearse parked in the front. The sign on the front reads, "Columbia Undertaking Co., F. W. Rasmussen." (Courtesy Rainier Valley Historical Society, No. 93.001.060.)

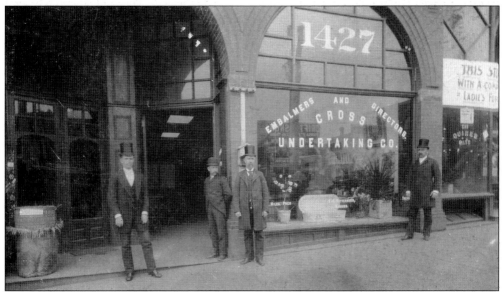

CROSS UNDERTAKING. This c. 1890 photograph shows Cross Undertaking on 1427 Front Street in Centralia, Washington. Standing in front of it, third from the left, is Bert Butterworth Jr.'s great-great-grandfather Edgar Ray Butterworth. The others are unidentified. (Courtesy Bert Butterworth Jr.)

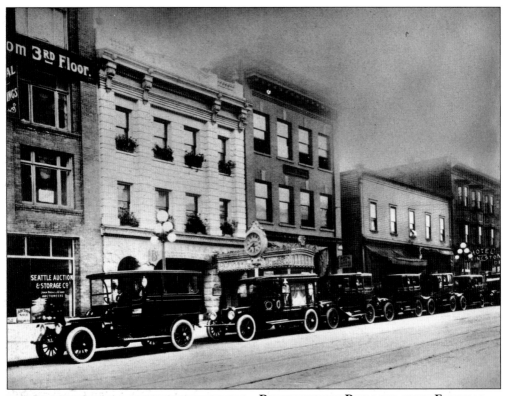

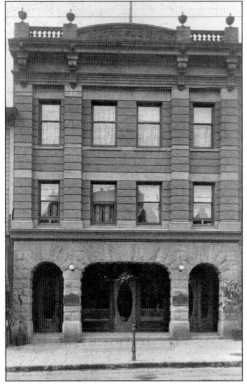

BUTTERWORTH BUILDING WITH FUNERAL PROCESSION. This is a photograph of a funeral procession parked along the sidewalk in front of the Butterworth Building on First Avenue in downtown Seattle sometime before 1917. (Courtesy Seattle Municipal Archives, No. 31718.)

BUTTERWORTH BUILDING. This full frontal view of the Butterworth Building was taken shortly after it opened in 1903. The building had five floors, with the chapel, family room, and general office on the first floor. The second floor had some private offices and waiting room. The third floor had the casket display room. The first basement floor is where the preparation room was located, as well as the casket trimming room and columbarium and crematory, which were added in 1914. The lower basement held the stables for the horses and coaches. (Courtesy Bert Butterworth Jr.)

BUTTERWORTH FAMILY, C. 1905. This picture was taken under the archway at 1921 First Avenue, Seattle. From left to right are the following: unidentified, Charles Norwood Butterworth (1897–1928), Benjamin Kent Butterworth (1893–1922), Edgar Ray Butterworth (1847–1921), unidentified, Gilbert M. Butterworth, and Nathan Anderson. E. R. Butterworth constructed this building in 1903. (Courtesy Bert Butterworth Jr.)

EDGAR RAY BUTTERWORTH. Butterworth was born in Newton Upper Falls, Massachusetts, on March 3, 1847, a son of William Ray and Eliza (Norwood) Butterworth. Butterworth came to Washington to engage in the stock-raising business. He became one of the early businessmen of Seattle, where he founded the undertaking business of E. R. Butterworth and Sons. After a long and lingering illness, he departed this life on January 1, 1921. (Courtesy Bert Butterworth Jr.)

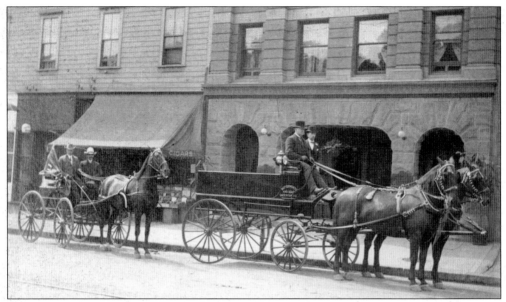

CALL CAR. This is the first call car for transporting the deceased to the funeral home and a utility vehicle behind it. Charley Butterworth is on the far side of the lead vehicle. Edgar Ray Butterworth would write off of his books the names of those who were not able to pay, a splendid illustration of practical charity. (Courtesy Bert Butterworth Jr.)

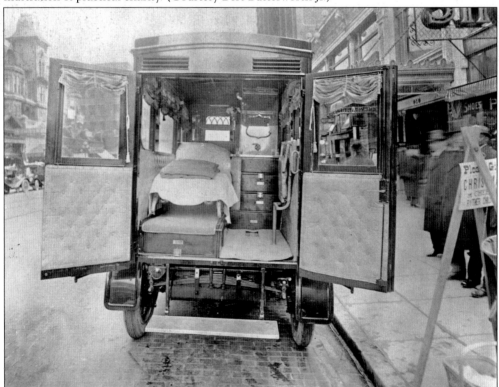

EARLY AMBULANCE. This photograph shows the interior of an ambulance used between 1900 and 1920. (Courtesy Bert Butterworth Jr.)

FRED BUTTERWORTH. "Fred was born 25 Dec 1877 at Mule Creek, Kansas, the son of Edgar Ray and Maria Louise Butterworth. When Fred was four years old, his father sold his cattle interests and moved to Lewis County in the Washington Territory. In 1892, the family moved to Seattle, and it was here that Fred received his education, and here that he always afterwards made his home. Attending Denny School, he supplemented this with one year of high school, after which he left school to begin his active career, taking a job as a baker's helper. For a few months he worked in the bakery and then entered his father's business as an apprentice mortician. His first duties were to take charge of his father's large stables. Upon his father's death in 1921, he and his older brother, Gilbert M. Butterworth, shared the partnership of the firm." (Information courtesy Bert Butterworth Jr., as compiled by Ritajean Butterworth, a granddaughter-in-law of Fred Butterworth.)

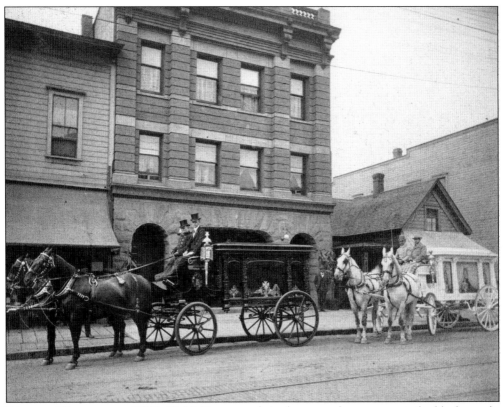

Funeral Coaches, c. 1905. G. M. Butterworth is closest to the camera on the black coach, which was used for adult men, and Charley Butterworth is closest to the camera on the white coach, which was used for women and children. (Courtesy Bert Butterworth Jr.)

Bodies in Drawing Room. Here lie the bodies of Col. Carl Ben Eielsen and Earl E. Borland in state in the drawing room of the Butterworth Mortuary. Butterworth was a man of very progressive spirit and it is believed that he was the first to introduce the words "mortuary" and "mortician" in connection with the undertaking business. (Courtesy Bert Butterworth Jr.)

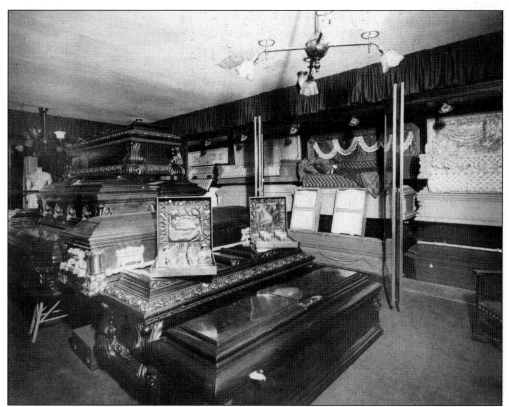

CASKET DISPLAY ROOM. The large display room was filled with carefully selected stocks of fine funeral furnishings to be found in the entire country, ranging in price from the most simple to the magnificent, stately designed solid bronze receptacles. (Courtesy Bert Butterworth Jr.)

COLUMBARIUM. In the Butterworth's building, the columbarium was located on the first floor. Bert Butterworth Jr., when looking at old photographs, said, "I remember when my cousin, Dave, and I played hide-and-go-seek in the mortuary, the fireside room and slumber room. We had names for all of the rooms like the flag room, but when we ran out of names we just called them A, B, C, D, etc. I went into the fireside room and opened a casket. . . . Oops. That's not my cousin! We didn't play hide-and-go-seek anymore." (Courtesy Bert Butterworth Jr.)

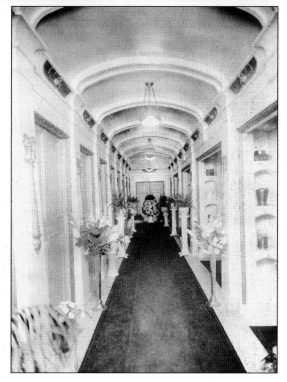

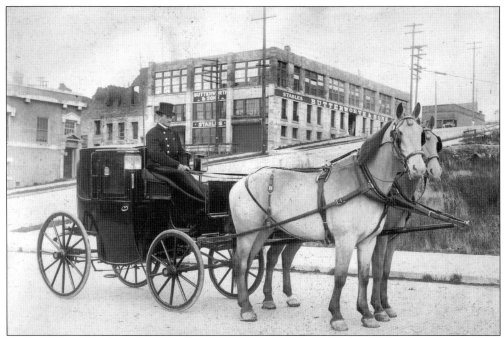

BUTTERWORTH AND SONS STABLES. Pictured around 1915 is the large building that housed the horses, hearses, ambulances, and other livery vehicles. (Courtesy Bert Butterworth Jr.)

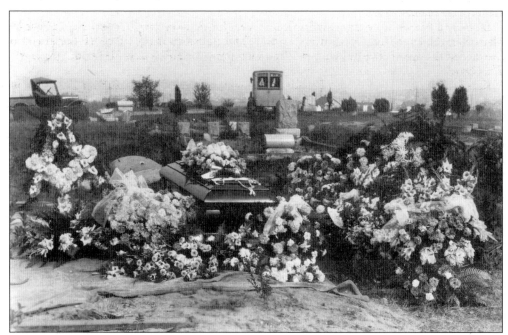

CROWN HILL CEMETERY. In 1903, Crown Hill Cemetery was established in 1902 and is operated as a nonsectarian business. When Greenwood Cemetery closed in 1907, some of the early Crown Hill Cemetery burials were removals from Greenwood. (Courtesy Laura McLeod.)

Five

THREE FAMOUS SEATTLE LANDMARKS

Seattle's most famous three grave sites are where Bruce and Brandon Lee, Kurt Cobain, and Jimi Hendrix are memorialized.

Bruce and Brandon Lee are buried at Lake View Cemetery on top of Capital Hill in Seattle. Martial-arts film star Bruce Lee died at the age of 32 from a cerebral hemorrhage. His son Brandon Lee died at the age of 28 after being shot by an improperly loaded gun while filming the movie *The Crow.*

Kurt Cobain is not yet buried, but his unofficial memorial benches are in Viretta Park in Seattle. Cobain was the lead singer of the Seattle grunge band Nirvana. On April 5, 1994, he committed suicide.

Jimi Hendrix is buried at Evergreen Memorial Park in Renton. The electric guitar player extraordinaire died before his time at the young age of 27. The left-handed Hendrix taught himself how to play a right-handed guitar as a young boy. In 1966, he formed his first band in London, called the Jimi Hendrix Experience. Their first single, "Hey Joe," quickly went to the top 10 in the United Kingdom. Other famous hits were "The Wind Cries Mary" and "Purple Haze." In June 1967, Hendrix pounded, smashed, and burned his guitar before an audience of 50,000 at the Monterey Pop Festival in California. He later released more songs, including "Up From the Skies" and "Axis: Bold as Love." One of his most memorable performances was his version of "The Star Spangled Banner" at the Woodstock festival in New York.

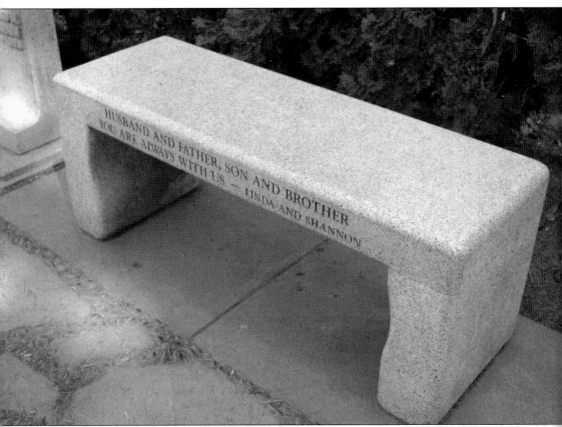

Bruce and Brandon Lee Memorial Bench. Lake View Cemetery, just north of Volunteer Park on Capitol Hill at 1554 Fifteenth Avenue East in Seattle, serves as the final resting place for Bruce Lee (1940–1973). He is buried under the red-granite monument, inserted with a Hong Kong–made ceramic picture. His beloved son Brandon (1965–1993) is buried under the black-granite monument. On the memorial bench is this inscription: "Husband and Father, Son and Brother. You are always with us—Linda and Shannon." Stop at Lake View Cemetery office located across from the cemetery to pick up a map to locate the Lee monuments. If the office is closed and the cemetery gates are open, then you may proceed on the road toward the top of the hill. Look for a large red-marble gravestone marker beside a similarly sized black marble gravestone marker adjacent the road towards the front of the hill.

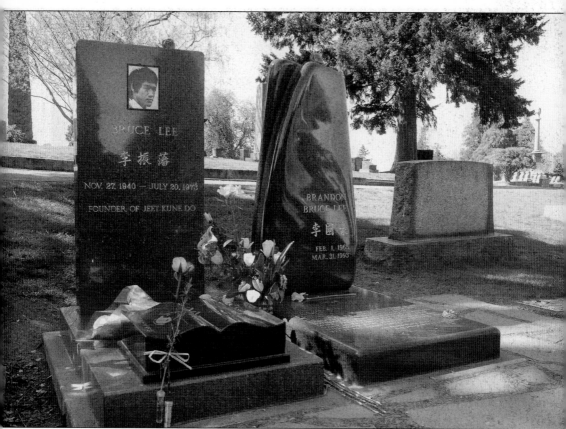

BRUCE AND BRANDON LEE MONUMENTS. The graves of Bruce and Brandon Lee, located side by side on the central hill, attract mourners from around the world. People inspired by the teachings of Jeet Kung Do or the Lee family legend are continually adorning the graves with offerings of flowers and coins. Bruce's grave site marker has this inscription: "Because we don't know when we will die, we get to think of life as an inexhaustible well. Yet everything happens a certain number of times and a very small number, really. How many more times will you remember a certain afternoon of your childhood, some afternoon that's so deeply a part of your being that you can't even conceive of your life without it? Perhaps four or five times more. Perhaps not even that. How many more times will you watch the full moon rise? Perhaps twenty. And yet it all seems so limitless. For Brandon and Eliza / Ever Joined in True Love's Beauty." (Courtesy Cherian Thomas Photography, Lot 276.)

VIRETTA PARK. At the foot of East John Street at 39th Avenue East, down to Lake Washington Boulevard is the 1.8-acre Viretta Park, named after C. L. Denny's wife, Viretta Jackson Denny, a relative of Pres. Andrew Jackson.

KURT COBAIN'S MEMORIAL BENCHES. Viretta Park has two benches that are covered by graffiti and memorabilia to Nirvana rock star Kurt Cobain (1967–1994). The park is located between the former homes of Kurt Cobain to the south and Starbucks chairman Howard Schultz to the north.

CHRIS NOVOSELIC VISITS MEMORIAL BENCH. On Holy Saturday 2007, a very special visitor paid his respects at Cobain's memorial bench. While cyclists and motorists drove past seemingly undisturbed, Nirvana band member Krist Novoselic, dressed in a dark pinstriped suit, descended from a path just behind the memorial bench. He left behind a dozen white roses and a card. With his head bowed, Novoselic stood motionless for a few moments before disappearing up the same path he came down. Author Robin Shannon happened to catch this private moment.

FOREVER IN DEBT. This is a close-up of the card left by Krist Novoselic. Quoting from the Nirvana song "Heart-Shaped Box," the card says, "Forever in debt to your priceless advice / Love, Holy Saturday 2007."

KURT COBAIN'S MEMORIAL BENCHES. These photographs show Cobain's memorial benches in Viretta Park. Thousands of adoring fans have visited the park since the fateful day of Cobain's death. From around the world, fans come to visit and leave flowers or light candles on the benches in the park next to the home where Cobain took his life. (Courtesy Cherian Thomas Photography.)

Photographer Cherian Thomas Ponders Cobain. On the day before Easter in 2007, photographer Cherian Thomas, from Toronto, Canada, muses that, "by looking at the bench, I understand from the names of Cobain's fans just how varied his fan base is. The names span from North American names to the Far East. His music and lyrics continue to validate Nirvana's popularity even today."

Close-up of Memorial Bench. Fans often carve messages into Cobain's memorial bench, such as this lyric from one of his songs: "Forever in debt to your priceless advice."

JIMI HENDRIX MEMORIAL. Every year on his birthday, November 27, hundreds of fans from around the world come to the memorial to celebrate Jimi Hendrix. In 1968, Hendrix said, "It's funny the way most people love the dead. Once you are dead, you are made for life." (Courtesy Cherian Thomas Photography.)

JIMI HENDRIX SIGNATURE. Guitar legend Jimi Hendrix was born Johnny Allen Hendrix in Seattle on November 27, 1942. His father, Al Hendrix, later changed his son's name to James Marshall Hendrix. Jimi Hendrix died in London on September 18, 1970, and his death certificate reads as follows: "Inhalation of vomit; barbiturate intoxication (quinalbarbitone); insufficient evidence of circumstances; open verdict." He was buried on October 1, 1970, at Greenwood Cemetery in Renton, Washington. (Courtesy Cherian Thomas Photography.)

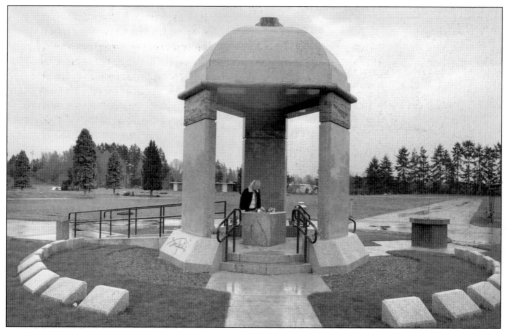

JIMI HENDRIX MEMORIAL. Robin Shannon is pictured above visiting Hendrix's grave in 2007. On October 6, 1999, Jimi's father, Al Hendrix, wrote to the fans, "A resting-place for a loved one is almost always a private issue dealt with quietly by family members. However, I have always understood that Jimi in some way belongs to his fans and the world." In 1999, Al Hendrix and his daughter Janie Hendrix commissioned architect Mark Barthelemy to design the huge memorial. Incorporated into the design are themes from Hendrix's music, his beliefs, and involvement with family members. The close-up below shows flowers atop an engraved stone that expresses the sentiment of many fans: "Forever in Our Hearts." (Both images courtesy Cherian Thomas Photography.)

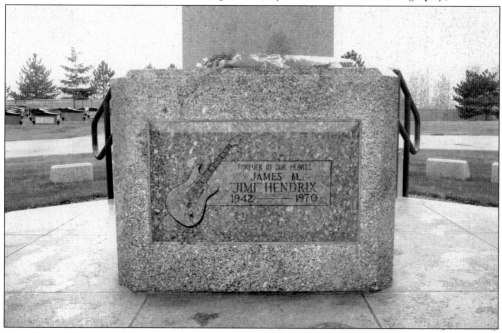

ACROSS AMERICA, PEOPLE ARE DISCOVERING SOMETHING WONDERFUL. THEIR HERITAGE.

Arcadia Publishing is the leading local history publisher in the United States. With more than 4,000 titles in print and hundreds of new titles released every year, Arcadia has extensive specialized experience chronicling the history of communities and celebrating America's hidden stories, bringing to life the people, places, and events from the past. To discover the history of other communities across the nation, please visit:

www.arcadiapublishing.com

Customized search tools allow you to find regional history books about the town where you grew up, the cities where your friends and family live, the town where your parents met, or even that retirement spot you've been dreaming about.